IMAGES
of America

WINCHESTER

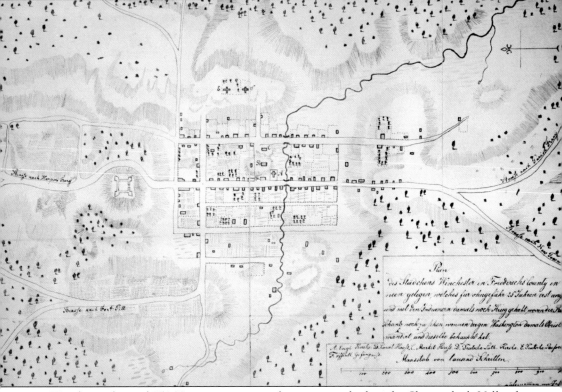

Winchester housed 750 Hessian prisoners who were marched to the Shenandoah Valley from Washington's victorious Battle of Trenton on December 26, 1776. Later 400 prisoners were dispersed to five other Shenandoah Valley towns with the remainder staying in Winchester. Hessian prisoner Lt. Andreas Wiederholdt, a mapmaker, was allowed to walk the town. He drew this map, and its proportions are accurate. (Courtesy Rare Book and Manuscript Library, University of Pennsylvania.)

ON THE COVER: Four young women celebrate Shenandoah Apple Blossom Festival in front of the Capitol Theatre at 48 Rouss Avenue. They are riding in a Packard Phaeton decorated for the festival in about 1929. The car's dual-cowl windshield folded down toward the front seat to allow access to the backseat. The Winchester Chamber of Commerce office was located at 50 Rouss Avenue. (C. Fred Barr, photographer; courtesy Stewart Bell Jr. Archives.)

IMAGES
of America

WINCHESTER

Kathryn Parker

ARCADIA
PUBLISHING

Published by Arcadia Publishing
Charleston, South Carolina

Printed in the United States of America

Library of Congress Catalog Card Number: 2006926326

For all general information contact Arcadia Publishing at:
Telephone 843-853-2070
Fax 843-853-0044
E-mail sales@arcadiapublishing.com
For customer service and orders:
Toll-Free 1-888-313-2665

Visit us on the Internet at www.arcadiapublishing.com

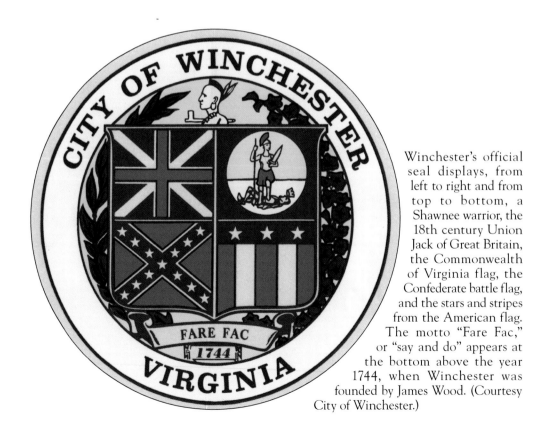

Winchester's official seal displays, from left to right and from top to bottom, a Shawnee warrior, the 18th century Union Jack of Great Britain, the Commonwealth of Virginia flag, the Confederate battle flag, and the stars and stripes from the American flag. The motto "Fare Fac," or "say and do" appears at the bottom above the year 1744, when Winchester was founded by James Wood. (Courtesy City of Winchester.)

CONTENTS

ACKNOWLEDGMENTS

I wish to show sincere appreciation and gratitude to Patricia "Patt" Hoffmann for editing so thoroughly and for her constancy throughout this project. Special thanks go to Trish Ridgeway, who recommended me to Arcadia and who gave me her full support. A great big thank you goes to Ben Ritter for his photographs, excellent memory, and lifelong acquisition of local historical facts. My gratitude goes to Pat Ritchie for her valuable experience and support.

My heartfelt thanks go to all who offered their photographs, knowledge, and support, whose names appear below. I want to especially thank Bill Madigan, Mike Foreman, Katy Pitcock, and J. Floyd Wine. My special thanks also go to the Joint Archives Committee of Stewart Bell Jr. Archives for permission to use their photographs; Barbara Dickinson and Rebecca Ebert brought materials to me tirelessly while researching at the archives. I wish to give sincere thanks to my Arcadia Publishing team, in particular to my editors, Kathryn Korfonta and Courtney Hutton, whose patience astounded me.

The generosity of the people of Winchester and the area deeply touched me. Many opened their files, their safe deposit boxes, and even their hearts. They warmed to the topic of Winchester and told me story after story. Everyone wanted to help and was enthusiastic about seeing this pictorial history complete. I hope you enjoy it as much as I have enjoyed researching and writing it.

Jane Ailes
Julie Armel
Lou Attard
Norman Baker
Betty Barr
Diane Berry
Ron Blunt
Jennifer Bowers
John Boyd
Leila Boyer
Arthur Bragg
Charles Brill
Rabbi Jonathan Brown
Wayde Byard
Jean Callum
Leticia Chavez
Johan T. Coates
Sally Coates
Sammy Copenhaver
June C. Gaskins Davis
Roger Delauter
Ann Denkler
Betty Jo Dickerson
John Doerner
Joanie Evans
Mary Fishback
Helen Lee Fletcher
Robert "Bobby" Ford
Charlotte Fritts
Lada Fulgenzi
Robert Grogg
Sharen Gromling

Harry Hall
Malcolm Harlow
Bettina Helms
Norma Rae Henry
Robert "Bobby" Henry
Ronna Hoffmann
Warren Hofstra
Judy Humbert
Maral Kalbian
Merrill Kerns
Priscilla Lehman
Sam Lehman
Dale Lehnig
John Lewis
Marjorie Lidoff
Carolyn Marker
Clark Nail
June Norwood
Dollie-Mae Shurtleff Parker
J. W. Parker
Kim Parker
Pam Peacemaker
Pirate, Tinsel, Tasha, and Cricket
Cephe Fahnstock Place
Suzanne Polkowske
Robert Russell
Amelia Rutledge
Alice Sanders
Amy Simmons
Joel Smith
Olivia Smith
Victoria Smith

Richard Stephenson
Donald Stewart
Effie Ashby Streit
Karen Swanson
Chris Thaiss
Sharron Todd
Francine Tolson
Kathleen Trzeciak
Alice and Barry Vance
Carol Weare
Timothy Youmans
Leighanne Zeigler
Charles Zuckerman
Kitty Zuckerman
City of Winchester
Handley Regional Library (HRL)
HRL Reference Department
Library of Congress
Museum of the Shenandoah
 Valley
New York Public Library
Pifer's Office Supply
Stewart Bell Jr. Archives
University of Pennsylvania, Rare Book
 and Manuscript Library
Water Street Designs
The Western Reserve Historical
 Society, Cleveland, Ohio
Winchester–Frederick County
 Historical Society
Winchester Printers, Inc.
The Winchester Star

INTRODUCTION

Native Americans may have come to the Shenandoah Valley about 11,000 years ago. This theory states that by 1670, these populations were driven out by the League of Iroquois, who were seeking the land for hunting grounds. The last Native Americans to live in the valley may have been of Central Algonquian stock. Stories of Shawnee camps in and near Winchester before 1750 have been passed down, but archaeological evidence has traditionally indicated that by 1700, the only Native Americans in the valley were raiders in the French and Indian War and those passing through. However, local archeologists believe that Native Americans were living in the valley at the time of European contact.

Winchester was the first English town west of the Blue Ridge Mountains, the frontier in the 1730s. Virginia's colonial governor William Gooch wanted it settled for many reasons. He granted large chunks of land to men like Jost Hite, the Van Meters, Morgan Bryan, and Alexander Ross, who agreed to distribute the land to many more settlers who would stay and farm. For enticement, the colonial governor allowed Quakers, Lutherans, and other Protestants to practice their faiths without joining the Church of England.

In his lifetime, George Washington spent more of his time in Winchester than any other place other than the capital. This was a town run by colonial government, and it was in Winchester that Washington first ran for office. The area in and around Winchester is also the site of many French and Indian War forts and stockades. The largest of these was Fort Loudoun, designed and built by Washington in Winchester. Knowing this area well from his work in Winchester, George Washington came to rely on respected citizens such as James Wood (Winchester's founder) and Daniel Morgan (one of Washington's generals), who became the leaders of the day.

Winchester was important during the Civil War because it was the gateway to the Shenandoah Valley—the breadbasket of the South. The town of Winchester changed hands over 70 times during the four years of the war. We know this because of four ordinary women who wrote diaries from inside occupied Winchester during this terrible time of upheaval. It took hard work for Winchester citizens to put the town and their lives back together after the destruction of the war. But they came out of it the stronger.

Though the Civil War tends to dominate any view of 19th-century Winchester, much progress and innovation happened before and after the war. For instance, in 1808, Winchester built one of the first city water systems in the country. It was during this century that Winchester progressed from the very edge of the wilderness to a thriving town and a hub of commerce.

In the late 19th century, Winchester had a reputation as a center of learning. The number of private schools was disproportionate to the size of the community. It was known for the higher education opportunities offered to women who came from the far reaches of the country to study here. In the 20th century, Winchester's ordinary citizens were educated by a public school system that was largely the product of philanthropists who saw a need and filled it.

Business in Winchester over the past 262 years has included hotels, hospitals, professional organizations, and both large and small businesses. Winchester is home to major companies, such as National Fruit Products, which produces White House Apple products. Many Latinos are settling in Winchester now—the latest group to add their talents to the mix. Many people of all kinds are moving to Winchester. Construction is becoming a major industry. Apple orchards are being replaced with roads, new homes, shopping centers, and institutions. Wonderful museums all over Winchester speak to its rich past and, in so doing, foretell its future.

Winchester has existed through parts of four centuries. From the privileged to the poor, people of this town have made their mark. While Winchester has produced explorers, military leaders, and great business people, it has also produced talented craftsmen, musicians, singers, and at least one sports legend. The images in this book document the prosperous times, war times, and fun

times. They also document how the city's people, both famous and ordinary, have shown courage, fortitude, and resilience in making their particular contributions to the world.

One

THE EARLY YEARS

Winchester founder James Wood, who died in 1759 at age 52, inscribed this *Book of Common Prayer* and gave it to his bride, Mary Rutherford, on "Jan. 28, 1737/38." Around the same time, Wood, the first appointed Orange County surveyor, built a house on the property known today as Glen Burnie. The Woods had five children. In 1796, their oldest son, James Jr., became the 10th governor of Virginia. (Courtesy Museum of the Shenandoah Valley.)

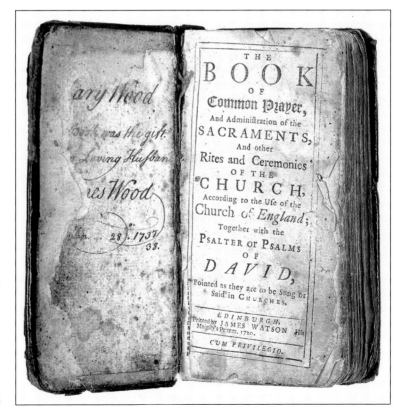

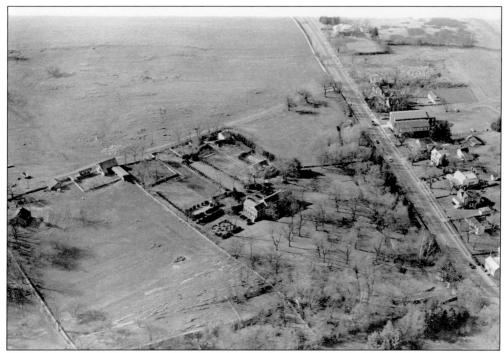

Over 30 years have passed since this aerial photograph of Glen Burnie (looking west) was taken in February 1976. The area around the Glen Burnie property is now developed. Churches, medical businesses, and new homes fill the area. Today the 254-acre property is the largest green space in the city of Winchester and is the only working farm remaining in the city limits. (Courtesy *The Winchester Star.*)

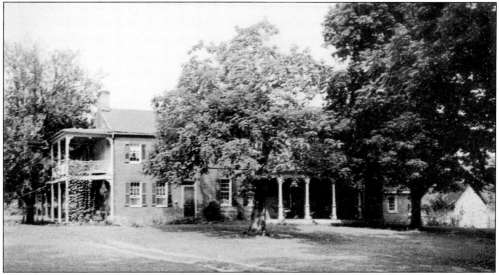

This shows Glen Burnie House prior to its transformation by Julian Wood Glass Jr. (1910–1992) in the mid-1900s. Born in Winchester, J. Wood Glass Sr. (1880–1952) became a successful businessman in Oklahoma. Glass began to restore his family homestead but died before he finished. However, through inheritance and purchase, he acquired enough of the land so his son could attain what he could not. (Courtesy Museum of the Shenandoah Valley.)

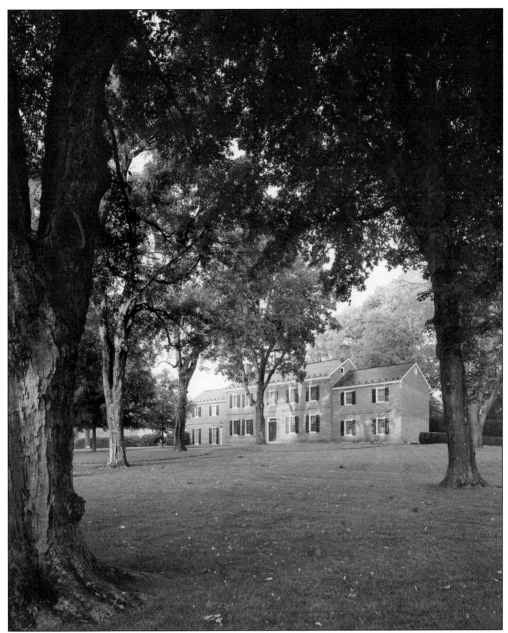

Julian Wood Glass Jr. preserved and furnished his ancestral home and created a foundation to open the historic property as a museum. The Glen Burnie Historic House that greets visitors today was built by Robert Wood, son of James Wood, in 1794. The location of the original Wood house remains a mystery. Frederick County was established from Orange County in 1738. Tradition holds that the first Frederick County court sessions were held on the Glen Burnie property around 1743, when James Wood became the county's first clerk of court. One year later, Wood plotted a town called Frederick Town on 26 half-acre lots of his land, in addition to 4 lots for public use. The town lay east of Glen Burnie. In 1752, the new town was recognized by the Virginia legislature. It was renamed Winchester and was the first English-speaking town west of the Blue Ridge Mountains. (Ron Blunt, photographer; courtesy Museum of the Shenandoah Valley.)

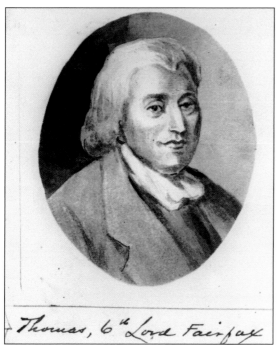

Thomas, Lord Fairfax (1693–1781), was born at Leeds Castle in Maidstone, Kent, England. He came to America in 1747 to settle the land granted to his ancestors in 1649 by Charles II. He led the militia and was justice of the Frederick County Court. He allowed religious dissenters to build churches on his land and was a well-loved proprietor. (James E. Taylor, illustrator; courtesy the Western Reserve Historical Society, Cleveland, Ohio.)

Thomas, 6ᵗʰ Lord Fairfax

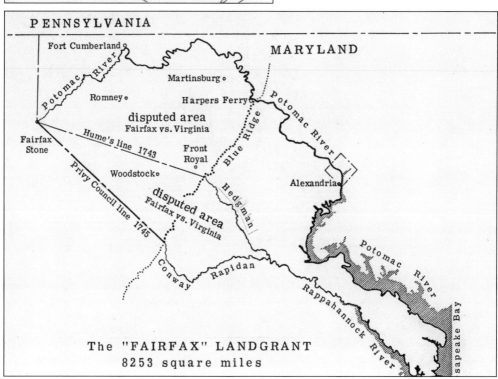

The "FAIRFAX" LANDGRANT
8253 square miles

This is an outline of the Fairfax proprietary. It included 5.7 million acres of wilderness and encompassed the land between the Potomac and Rappahannock Rivers to their headsprings. This property was settled through land grants, including those that became Winchester. Much of the property was surveyed by George Washington. (Courtesy Sam Lehman, mapmaker.)

Joseph Vance, a local ninth-grader, had the original idea to erect a statue of the young surveyor, George Washington. Retired judge Robert K. Woltz, then Winchester–Frederick County Historical Society president, asked the community for suggestions to celebrate George Washington's time in the Winchester area. Vance was active in many aspects of this project. The historical society raised $50,000 to pay for the life-size statue, which was dedicated in 2004. (Courtesy Ronna M. Hoffmann, photographer.)

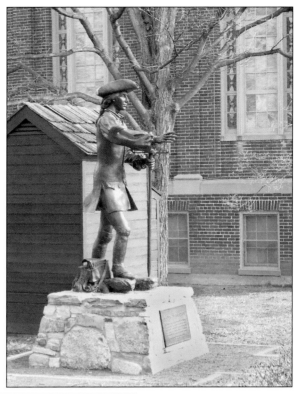

Malcolm Harlow, sculptor of the George Washington statue, has had a long career as an artist in Greater Washington, D.C. One of the last stonecutters of cathedrals, he carved gargoyles for the National Cathedral. He worked with the Smithsonian and the National Park Service in researching for this statue. Harlow was intent on making Washington historically correct with proper riding coat, blousy shirt, buckles, and surveyor's bag. (Courtesy Malcolm Harlow.)

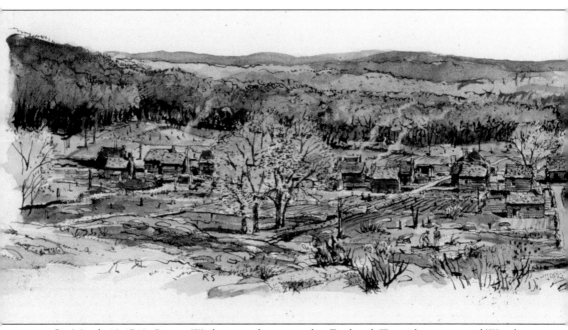

On March 16, 1748, George Washington first arrived in Frederick Town, later renamed Winchester, as part of a surveying expedition for Lord Fairfax. Earlier in the year, while staying with his half-brother, Lawrence, at Mount Vernon, Washington frequently visited another plantation, Belvoir, William Fairfax's estate. William, Thomas Lord Fairfax's cousin and agent, sent Washington on this expedition. Washington had recently passed his 16th birthday. He would leave this area 10 years later as an experienced, wiser man having established roots in all three of his careers—surveyor,

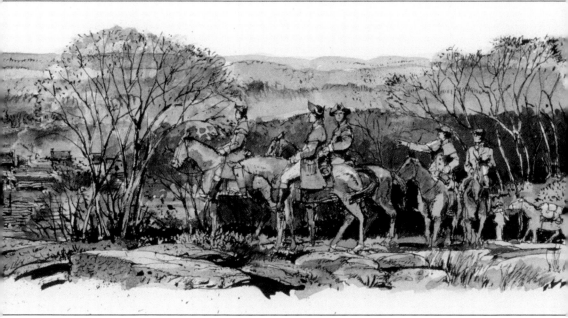

military leader, and politician. George Washington surveyed much of original Frederick County (now Berkeley, Clarke, modern Frederick, Hampshire, and Jefferson Counties), staying occasionally in Winchester. Washington ran for the House of Burgesses from Frederick County in 1755 and lost by a wide margin, probably because he was new to the area. He ran again and won in 1758 and won easily in 1761. The elections were held in Winchester, the county seat. (Richard Schlect, artist; courtesy Stewart Bell Jr. Archives.)

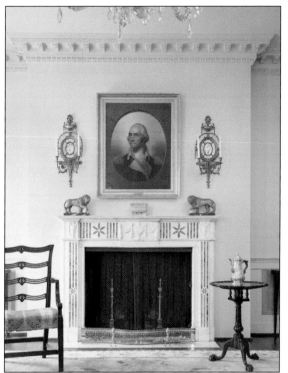

Acquired by Julian Wood Glass Jr., this portrait of George Washington (1732–1799) by Rembrandt Peale (1778–1860) around 1850 hangs in the drawing room of Glen Burnie House. Glass's ancestor Col. James Wood served in the Frederick County Militia, fought with Washington at Fort Necessity, and served as proxy for Washington in his 1758 election to the House of Burgesses. (Ron Blunt, photographer; courtesy Museum of the Shenandoah Valley.)

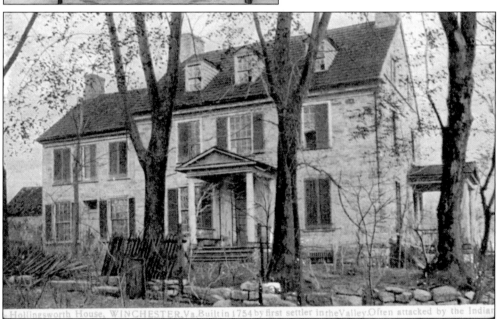

Abram's Delight is the oldest home in Winchester. Isaac Hollingsworth built this limestone house in 1754. His father, Abraham, was granted 582 acres in 1734, and he came to this area the following year. The Hollingsworths were Quakers. Looking for fertile land and religious freedom, many Quakers migrated from Pennsylvania. This photograph was taken before the extensive renovation by the Winchester–Frederick County Historical Society in the 1950s. (Courtesy Leighanne Zeigler.)

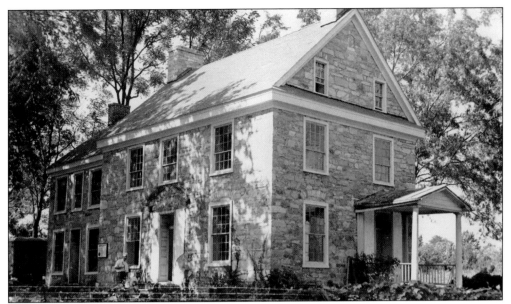

The man sweeping in front of Abram's Delight was Irvan Thomas O'Connell Sr. (1902–1990). Dr. E. C. Stuart Jr., O'Connell, Mary Boxley, and Helen Whiting led the restoration committee that began in 1951. The 18th-century house museum at 1340 South Pleasant Valley Road opened to the public in 1961. The Winchester–Frederick County Historical Society conducts tours from April through October, and their Web site is www.winchesterhistory.org. (Courtesy *The Winchester Star*.)

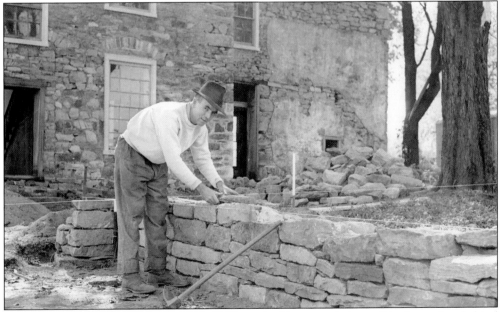

Dr. Emmett Christopher Stuart Jr. (1908–1988) was building a retaining wall in the gardens behind Abram's Delight when this picture was taken in the 1950s. Stuart, a surgeon, personally did a great deal of the work on the house. Irvan O'Connell was a plumbing and heating contractor by trade and, accustomed to restoring homes in Winchester, did all the plumbing and heating for the house. (Courtesy *The Winchester Star*.)

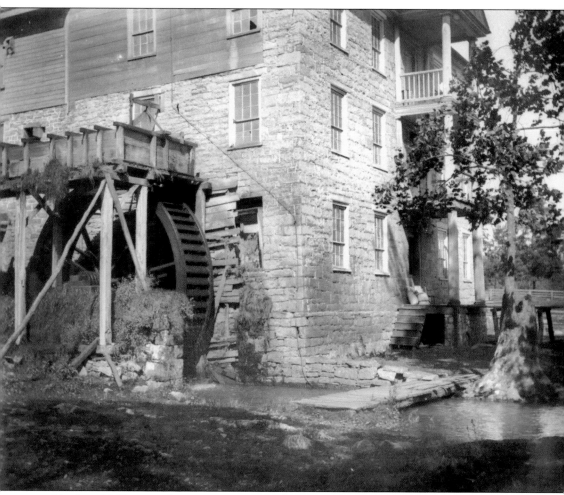

Abraham Hollingsworth was an enterprising businessman who had one of the first gristmills in the valley. This photograph of Hollingsworth Mill on Abraham's Run in Milltown on the Valley Pike was taken by the famous photographer Frances Benjamin Johnston about 1900. A description of the mill appears in *With Sheridan Up the Shenandoah Valley in 1864—Leaves from a Special Artists Sketch Book and Diary*. James Taylor described it in 1864 as situated on "the west side of the road, suddenly to our sight is revealed a three-story grist mill which with its triple-pillared balcony took on the aspect of a mansion grand but the illusion was quickly dispelled at sight of the big ugly waterwheel attached." The mill is no longer standing. Its location was on the west side of present-day Valley Avenue (Route 11) north of the former Elm's Restaurant and across the street from O'Sullivan Corporation. It probably stood between present-day Virginia Apple Storage and Valley Avenue. (Courtesy Library of Congress.)

In 1756–1758, George Washington supervised construction of Fort Loudoun in Winchester as a defense during the French and Indian War. The Fort Loudoun well was dug inside the fort by Washington's men. They dug 103 feet deep, through solid limestone. The Fort Loudoun Apartments at 411 North Loudoun Street are built where the fort stood. The well is located at the southwestern bastion of the fort. (Courtesy Leighanne Zeigler.)

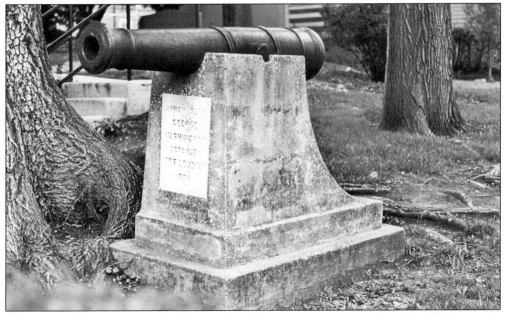

This is one of the cannons used at Fort Loudoun. Fourteen cannons were placed in the bastions in 1757. Ten 4-pounders came from Rock Creek near the Potomac and four 12-pounders from the center of Winchester. George Washington planned to mount 24 cannons, six in each of the four bastions. This cannon is now located at 32 West Cork Street. (Courtesy Ben Ritter, photographer.)

Nan Luckett (died 1861) was the first wife of William Wood Glass (1835–1911). This painting by the famous Winchester artist Edward Caledon Bruce (1825–1900) is one of several Wood/Glass portraits displayed in the Glen Burnie Historic House. A deaf writer and artist, Bruce also owned the Winchester-based *Virginian* newspaper. His self-portrait hangs in Winchester's Abram's Delight Museum. (Ron Blunt, photographer; courtesy Museum of the Shenandoah Valley.)

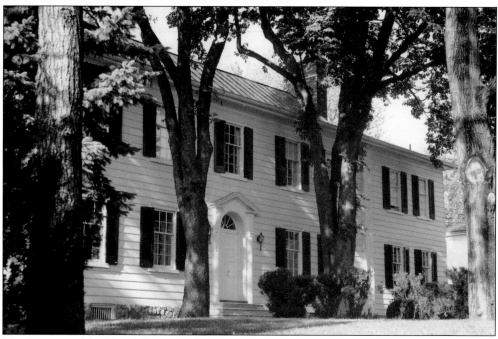

The first part of Ambler Hill, 223 Amherst Street, was built in 1786 on a part of the James Wood addition annexed to the town of Winchester. Like the Daniel Morgan house across the street, also built in 1786, it is still standing and in excellent condition. This home was the birthplace of John Esten Cooke (1830–1886), a financially successful Southern novelist and man of letters. (Courtesy *The Winchester Star*.)

This tall case clock, c. 1795, was made by Goldsmith Chandlee (1751–1821) for the Wood family and remains in the Glen Burnie Historic House. It was one of about 40 made and is original to Glen Burnie. Chandlee built a brass foundry and shop at the northwest corner of Piccadilly and Cameron Streets. He made surveyors' instruments and other items. (Ron Blunt, photographer; courtesy Museum of the Shenandoah Valley.)

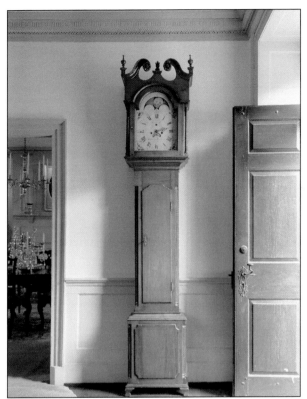

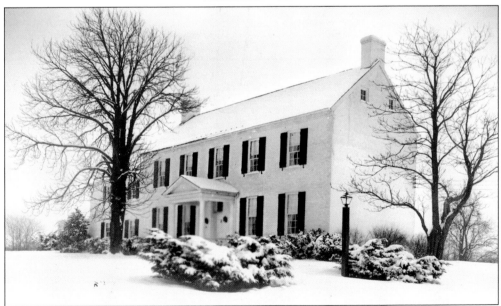

Rose Hill Farm, 234 Featherbed Lane, was built in sections before 1790 and about 1815 and was destroyed for a strip shopping center. C. Douglas Adams bought 13 acres, including Rose Hill Farm, from Hunter and Shirley Gaunt for $853,000 in 1986 to build Martin's grocery store, which stands where Rose Hill Farm stood. This property was originally owned by Abraham Hollingsworth, Winchester's first settler. (Barr's Studio, photography; courtesy *The Winchester Star.*)

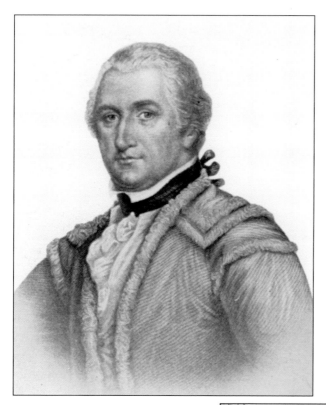

"Fought everywhere, was beaten nowhere." These words were Gen. Daniel Morgan's (1736–1802) own assessment of his Revolutionary War service. Morgan, a resident of Winchester, was one of the outstanding leaders of the American Revolution and led the army in a pivotal battle in Cowpens, South Carolina. For his service, Morgan was given a gold medal by Congress. (R. Hall, illustrator; courtesy Stewart Bell Jr. Archives.)

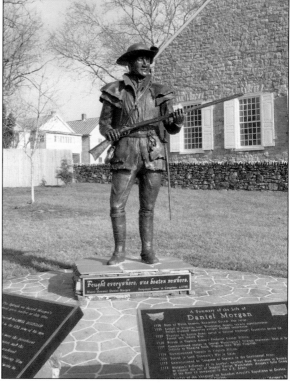

Daniel Morgan (1736–1802) was a member of Old Stone Presbyterian Church and was originally buried there. In 2005, the Daniel Morgan Memorial Foundation dedicated this statue on land donated by the church in its side yard. The memorial and statue were built with donated cash, labor, and materials. The eight-foot bronze statue, showing Morgan as a frontier rifleman, was created by Marsha Hardesty, an Oklahoma sculptor. (Courtesy Jean R. Callum, photographer.)

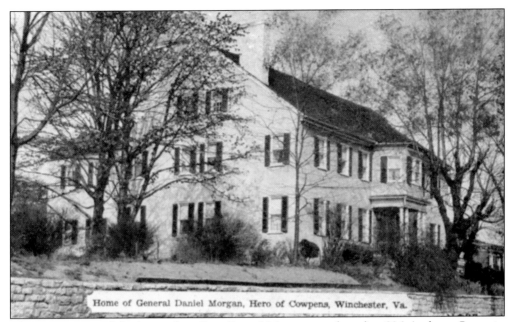

Home of General Daniel Morgan, Hero of Cowpens, Winchester, Va.

This is a picture of the home that Gen. Daniel Morgan purchased at 226 Amherst Street in Winchester in 1800. The hero of Saratoga and Cowpens died here in 1802 in his upstairs bedroom (the two windows on the far right front corner). The original house was built in 1786. Morgan added the northwestern portion of the house in 1800. The house still graces Amherst Street today. (Courtesy Leighanne Zeigler.)

This hearth is inside the Daniel Morgan home. Morgan was a rambunctious youth and frequently got into trouble for fighting and rowdiness. These tough tendencies, harnessed by the man that Morgan became, turned to steely courage. In addition to his military prowess, Morgan was elected to Congress in 1797. Much admired even now, a local group calling itself Morgan's Rifle Company honors the general's memory. (Courtesy *The Winchester Star.*)

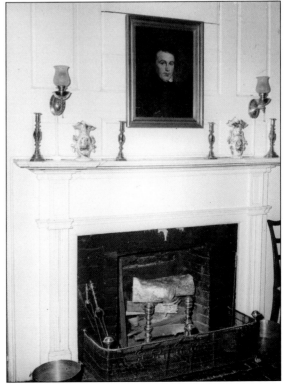

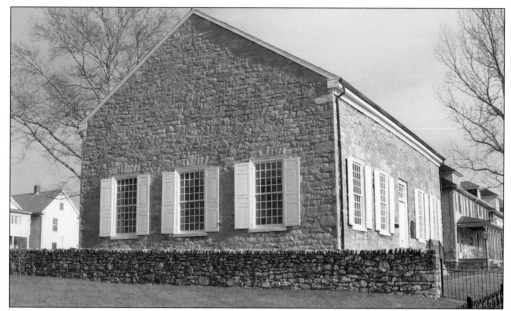

One of Winchester's oldest standing buildings, Old Stone Presbyterian Church, built in 1788 at 306 East Piccadilly Street, was a branch of the Opequon Church, built in 1736. The first Sunday school south of Pennsylvania organized here in 1815 and was used by Presbyterians until 1834. After that, it was used by Baptists; the Old School Baptist Church of Color; federal troops; African American children as a public school; and the National Guard. (Courtesy Jean R. Callum, photographer.)

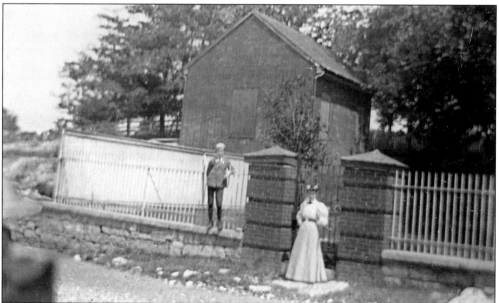

The old town spring was the first springhouse in Winchester. It was built by James Wood across from what is today Glen Burnie Historic House. Standing in the foreground in this photograph, c. 1890, are tourists Lou Hurst and Lewis Miller. The land belonged to Lawrence Washington when Winchester installed its water system. In 1840, it was purchased by Winchester from Thomas and Susan Tidball. (Courtesy Stewart Bell Jr. Archives.)

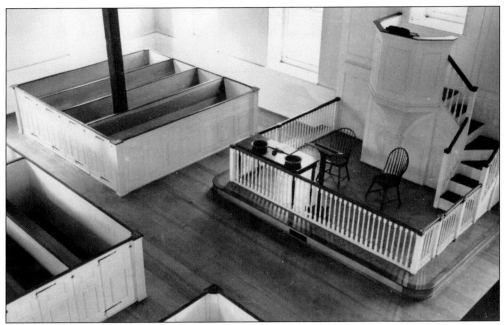

The Synod of Virginia met in the Old Stone Presbyterian Church in 1790 and 12 times subsequently. The general assembly of the Presbyterian Church in America met here in 1799. In 1932, the Presbyterian Church reclaimed the church by court decree. Clifford Grim, Fred Glaize Jr., and others led in the church's restoration. It was dedicated in 1950 during a Synod of Virginia meeting. (Courtesy Stewart Bell Jr. Archives.)

The first Winchester water system was installed in 1808. Buried wooden pipes, such as this one, were connected in two-foot lengths starting at Town Spring on Amherst Street and ending at Loudoun Street. A hole was drilled in the side so that individuals could connect to water from the system. Some iron pipes were laid around 1829. Lead pipes, installed in 1842, were not durable and were replaced by cast iron. (Photgraph by author.)

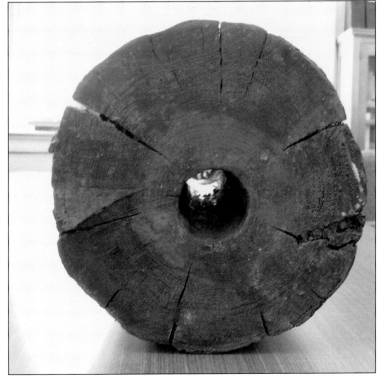

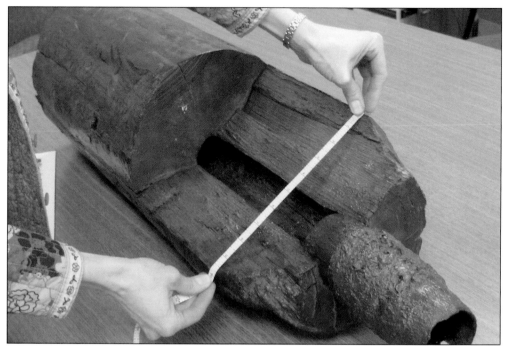

Winchester's wooden water pipes are still being found during road work in the city. Dale Lehnig, city engineer, measures this main system pipe as 10 inches wide with a two-inch bored hole. Service lines to private property had a one-inch hole. An iron sleeve, shown in the end of this cutaway pipe, was inserted in a second pipe, and they were pounded together. The pipes were further secured by an iron band on the outside joint. (Photgraph by author.)

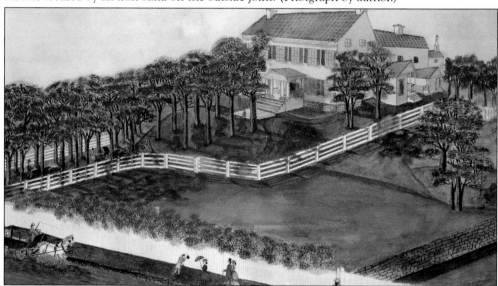

C. W. Hensell created this primitive of Aspen Hill at Stonewall and Lee Streets in 1840. This was the home of businessman Bushrod Taylor. It was sold after the Civil War and reopened as the Shenandoah Valley Academy for boys. The Equity Improvement Company bought it and built the Winchester Inn, a handsome building but a business failure. The inn and land were sold and subdivided. (Courtesy Handley Regional Library.)

Two

CIVIL WAR ERA

Robert Thomas Barton (1842–1917) was born in Winchester and was educated at the University of Virginia. He served in the Rockbridge Battery and as a captain in the ordnance department during the Civil War. He became one of the state's leading attorneys and wrote prized legal texts. He served in the House of Delegates (1884–1885) and was mayor of Winchester. (Courtesy Stewart Bell Jr. Archives.)

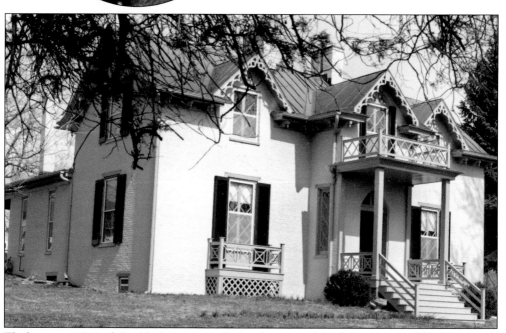

Nathaniel Routzahn took this famous photograph of Confederate general Thomas Jonathan "Stonewall" Jackson in 1862. The story told is that Jackson, when asked for his likeness, went to this photographer. When he arrived, his uniform was missing a button. Jackson sewed it back on but inadvertently placed it so that the left third button pulled the cloth. (Nathaniel Routzahn, photographer; courtesy Ben Ritter.)

The house at 415 North Braddock Street was the headquarters of Confederate general T. J. "Stonewall" Jackson (1826–1863) during the Civil War. Lt. Col. Lewis Tilghman Moore of the 4th Virginia Volunteers owned it and left from this house on January 1, 1862, to wage the Romney Campaign. It now belongs to the city of Winchester and is operated by the Winchester–Frederick County Historical Society. It is open to the public and can be accessed on the Web at www.winchesterhistory. org/Qstore/stonewalljackson.htm. (Ben Ritter, photographer; courtesy Ben Ritter.)

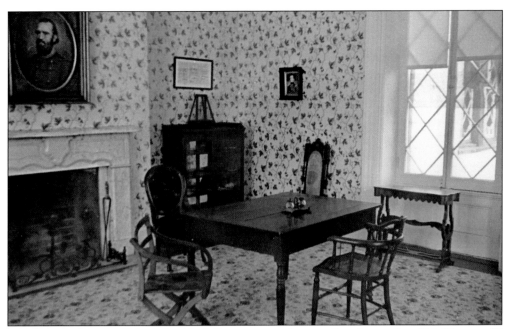

This front parlor at 415 North Braddock Street was used as an office during Gen. T. J. "Stonewall" Jackson's stay in Winchester in 1862. A sample of the original fig-leaf wallpaper was found when the house was restored. Actress Mary Tyler Moore, great-granddaughter of Lieutenant Colonel Moore, replaced the wallpaper by custom reproducing it exactly as it was. Moore visited the home in 1984. (Courtesy *The Winchester Star.*)

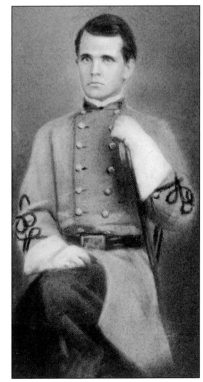

Holmes Conrad (1840–1915) was born in Winchester on January 31, 1840. He was educated at Virginia Military Institute and rose from private to the rank of major in the Confederate army, as well as becoming inspector general for Thomas Rosser's cavalry division. Conrad went on to become solicitor general of the United States. (Courtesy Handley Regional Library.)

Judge Richard Parker (1810–1893) was one in a line of three Virginia judges by that name. He tried famous cases, the most famous being the trial of John Brown in 1859 for his raid on Harpers Ferry. Parker lived in Winchester, but he tried Brown in Charlestown, Virginia (now West Virginia). America's newspapers praised Parker for presiding with dignity, firmness, and fairness to the prisoners. (Courtesy Stewart Bell Jr. Archives.)

This lovely foyer was in the home of Judge Richard Parker at 307 South Washington Street. It was built by Judge Hugh Holmes (1768–1825), who was mayor in 1795. It is tradition that he built the house with plans suggested by Thomas Jefferson. The property was contained within Washington, Clifford, Cecil, and Stewart Streets. The house was demolished about 1922. (C. Fred Barr, photographer; courtesy Stewart Bell Jr. Archives.)

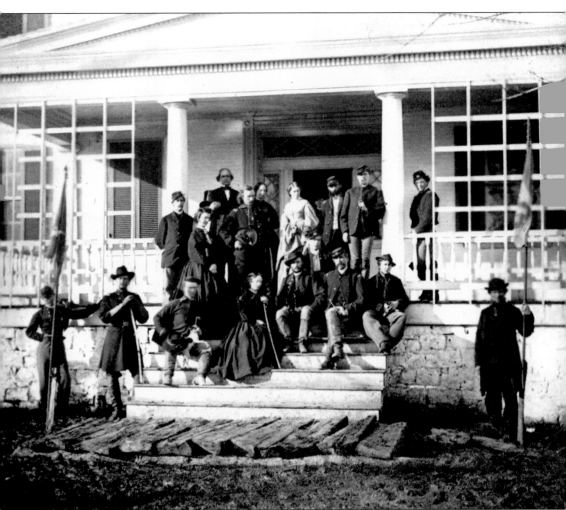

In this photograph, Maj. Gen. George Armstrong Custer (top step with his signature flowing blond hair) and his wife, Elizabeth Bacon Custer (on his right), entertain family and staff at Elmwood. This house was used as the first of two headquarters Custer had in Winchester. Elmwood burned down around 1920. It was located where the exit from Virginia Route 37 to U.S. Highway 50 West is today. A fearless man, Custer at 23 was one of the youngest generals in the Union army. The flag on the left was Custer's personal flag, a privilege accorded to generals. It was red on top and blue on the bottom with white, crossed sabers depicted. He used it from 1863 until he was killed in battle in 1876. He fought at the Third Battle of Winchester, Cedar Creek, and Fisher's Hill. (Courtesy Little Bighorn Battlefield.)

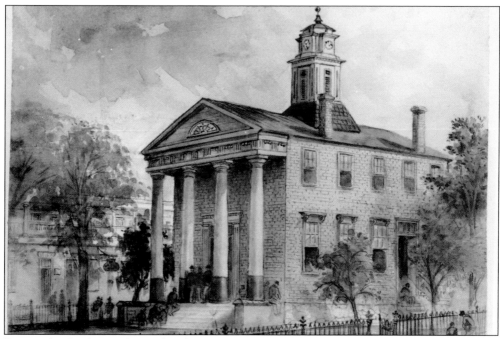

During the Civil War, the Frederick County Courthouse at 20 North Loudoun Street was used as a barracks, hospital, and prison. This sketch shows Confederate prisoners captured after the Third Battle of Winchester. Today its second floor is a museum called the Old Court House Civil War Museum, which contains a significant collection of Civil War artifacts. (James E. Taylor, illustrator; courtesy the Western Reserve Historical Society, Cleveland, Ohio.)

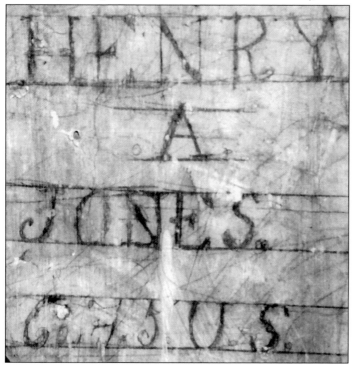

Visitors learn from prisoners who wrote on the courthouse walls. The museum has researched the "graffiti" and posted information on their Web site, www.civilwarmuseum.org, about the prisoners who left messages. Internet visitors might find ancestors, such as Henry A. Jones, 5th U.S. Cavalry, Company F, alias Henry A. Powell, with the 1865 occupation force. (Courtesy Old Court House Civil War Museum.)

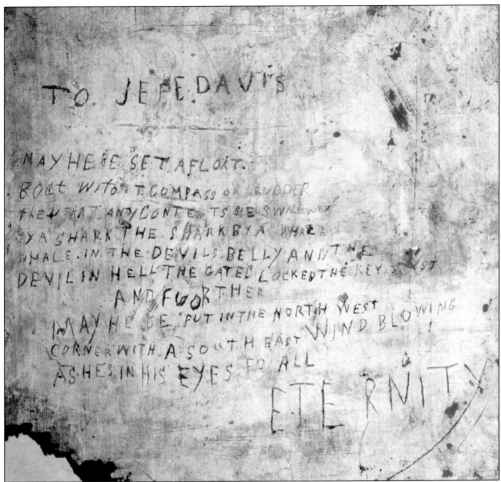

Visitors to the Old Court House Civil War Museum are enveloped by a dramatic time of history when the courthouse was used as a prison by both sides. During renovation, curators discovered dozens of names and messages scribbled on the walls by Civil War soldiers. This curse to Confederate president Jefferson Davis was written by one of the federal prisoners in 1863. "To Jeff Davis. May he be set afloat on a boat without compass or rudder. Then that any contents be swallowed by a shark, the shark by a whale. Whale in the devils belly and the devil in Hell, the gates locked, the key lost. And further may he be put in the north west corner with a south west wind blowing ashes in his eyes for all ETERNITY." (Courtesy Old Court House Civil War Museum.)

Or in the words of the Poet: "Faint Terrestrial rumblings salute

With the Showers Subsidence we leave the building, not without however, who had likewise there Sought Shelter! from whom Necessary to our progress — Returning to Key position i the tramp is resumed

The first residence we meet after leaving the Mill was that of its Owner, Abraham Hollingsworth 200 feet distance therefrom, and likewise on West Side of the Pike — an ample brick House secluded by shade trees =

The Miller Sported the Name in full of his Ancestor to Whose thrift he was indebted for Many broad acres in the Vicinity, and the Mill property as Well, and to their Credit be it said, the Mantle of Old Abraham Hollingsworth fell successively on Worthy Shoulders through the fourth in line to hold the property intact in the fami

Down the Pike We briskly pace exhilerated by the fragrent air the J. P. the Moisture Magnate, who had blossomed out thus for our benefi crests of the receding Cloud rolling nigh in the blue Abyss

A hundred yards from Hollingsworth dwelling lands us at t
The Valley pike at the identity as such in Staunton Street, whose run is 850 yards assumes the Name of London Street, which title holds good to the Martinsburg Pike

Two hundred feet in Staunton Street We encounter the firs frame house innocent of paint — Standing on the East side of

Seated just within the doorway were two members of the family Meeting Gowns — Being thirsty and encouraged by thei Request a drink of Water — Which Was obligingly furnis polite declination to their invite to enter and rest — as h

From Jacobs, the houses begun to Multiply and assume a Ve

In 1864, James E. Taylor traveled with Union general Philip Sheridan during his campaign in the Shenandoah Valley. A man with abundant talent, Taylor sketched virtually everything he saw on the long trek. After returning from the war, he spent eight years amplifying the diary and mounting the sketches. The result is called *With Sheridan Up the Shenandoah Valley in 1864*. His keen eye for detail and sense of scale enabled him to draw maps like this one. He fixed many of the important landmarks of the Shenandoah Valley. His map of Winchester shows the location of many of the places mentioned in this book: Hollingsworth Mill, Town Spring Run, the Lutheran church, the Episcopal church, the market, Taylor Hotel, Mount Hebron Cemetery, and Fort Loudoun. (Courtesy the Western Reserve Historical Society, Cleveland, Ohio.)

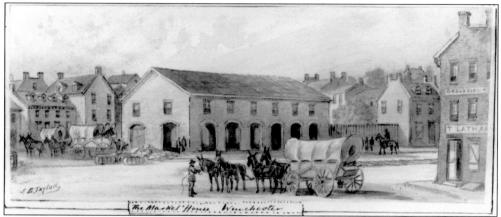

Market House was located at 15 North Cameron (Market) Street, behind the courthouse. Demolished in 1899, it was a two-story brick building used in 1864 as a depot for provisions. During the Civil War, the railroad followed the middle of Cameron (Market) Street and stopped at the mill at Town Run. A two-way buggy track ran beside the railroad. (James E. Taylor, illustrator; courtesy the Western Reserve Historical Society, Cleveland, Ohio.)

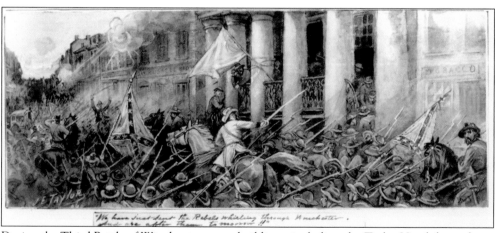

During the Third Battle of Winchester, many buildings, including the Taylor Hotel shown here, accommodated the wounded. The illustrator who was at the battle described this scene as a "dramatic spectacle of the whirling mass of gray madly pouring through the streets of Winchester amid shells shrieking and moaning." Many Confederate soldiers were killed or wounded in the war. (James E. Taylor, illustrator; courtesy the Western Reserve Historical Society, Cleveland, Ohio.)

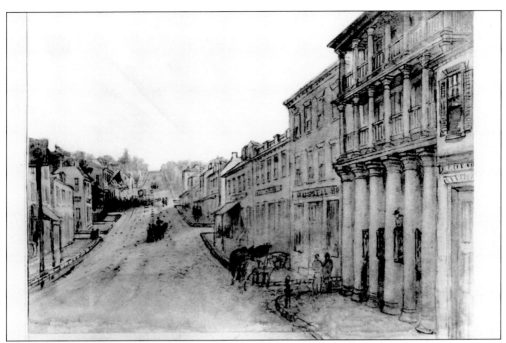

James E. Taylor described the Taylor Tavern as "a massive three-story brick structure, with basement, ornamented by two balconies, each with seven wooden pillar supports, seven white massive pillars of brick, plaster coated, resting on masonry neath the walk, sustained their weight." The columns are in the right foreground in this view of Loudoun Street, looking south. (James E. Taylor, illustrator; courtesy the Western Reserve Historical Society, Cleveland, Ohio.)

Union scouts found a loyal African American living near Berryville who had a permit from the Confederate commander to enter and leave Winchester three times a week. General Sheridan took Thomas Laws aside and asked him to deliver a message to Rebecca Wright, a young teacher living in Winchester. She was a Quaker and loyal to the Union. (James E. Taylor, illustrator; courtesy the Western Reserve Historical Society, Cleveland, Ohio.)

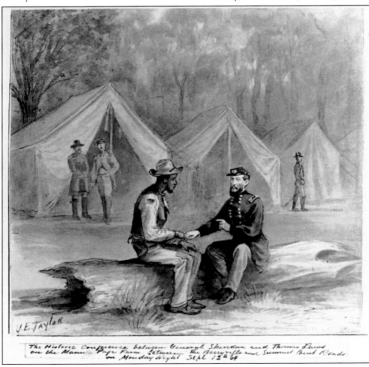

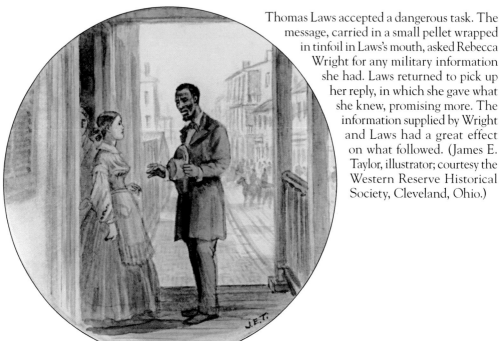

Thomas Laws accepted a dangerous task. The message, carried in a small pellet wrapped in tinfoil in Laws's mouth, asked Rebecca Wright for any military information she had. Laws returned to pick up her reply, in which she gave what she knew, promising more. The information supplied by Wright and Laws had a great effect on what followed. (James E. Taylor, illustrator; courtesy the Western Reserve Historical Society, Cleveland, Ohio.)

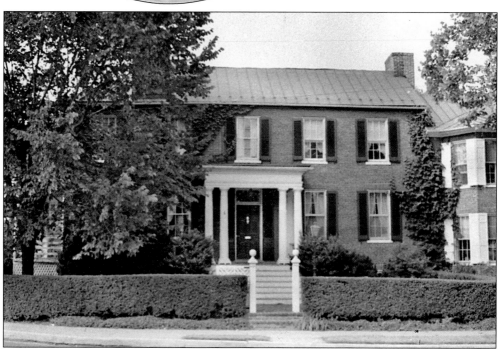

During the Civil War, the Henkel home on West Boscawen Street was one of many Winchester houses used as hospitals for wounded Confederate soldiers. The city changed hands about 70 times during the course of the war. When Union troops gained control of the city, the men were often carried out of these makeshift hospitals, then brought back when the Confederates regained possession. (Courtesy *The Winchester Star*.)

Hawthorne, a house previously owned by James Wood Jr., future Virginia governor, and Lawrence Washington, nephew of George Washington, probably experienced its most interesting events, during the Civil War. Cornelia McDonald, her eight children, two slaves, and three servants defended it against Union soldiers occupying Winchester. On June 14, 1863, an artillery duel was fought directly over the house. (Courtesy *The Winchester Star.*)

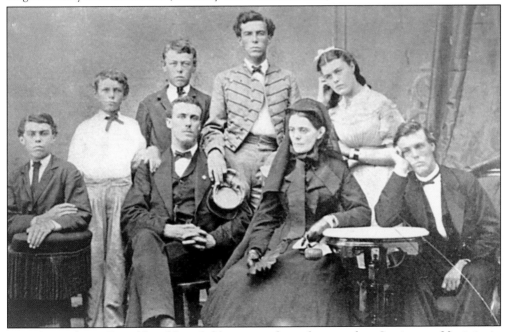

Cornelia Peake McDonald and her children unite for a photograph at Lexington, Virginia, in 1870. From left to right, they are as follows: (seated) Roy (1856–1921), Allan Lane (1849–1915), Cornelia (1822–1909), and Harry Peake (1848–1904); (standing) Hunter (1860–?), Donald (1858–1924), Kenneth (1852–?), and Ellen (1854–?). McDonald told the Winchester war experience in her diary, *A War Diary with Reminiscences* (1935). (Miley, photographer; courtesy Stewart Bell Jr. Archives.)

This was the home of Mary Charlston Greenhow Lee (1819–1907), 132 North Cameron Street, next to the George Washington Hotel. This picture was taken not long before the house was taken down. Lee kept a diary of her life during the Civil War. She intentionally broke every edict given by the Union occupying forces, and was finally exiled from Winchester by General Sheridan. (Courtesy *The Winchester Star.*)

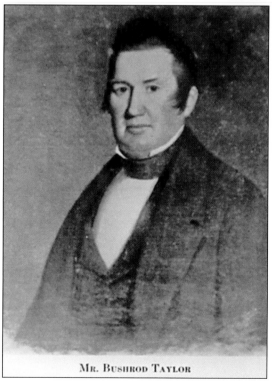

Mr. Bushrod Taylor

Bushrod Taylor (1793–1847) is best known for building and operating the Taylor Hotel on Loudoun Street, a Winchester landmark. Taylor had many business interests, including running a network of stagecoach lines. This led to an interest in building highways. He was the first president of the Valley Turnpike Company, which was responsible for building a macadam road from Winchester to Staunton. (Courtesy Ben Ritter.)

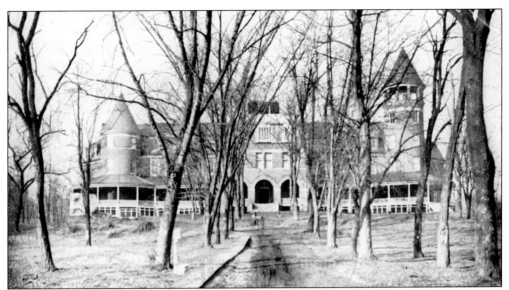

This is the entrance to the magnificent Winchester Inn, which stood on Stewart Street near Boscawen (Water) Street. Completed in 1891, financial problems delayed its opening until 1900, and it remained open for only a few months. The inn was built on land that had been home to Aspen Hill and Shenandoah Valley Academy. Although the inn was demolished in 1919, the driveway remains as Stonewall Drive. (Courtesy Leighanne Zeigler.)

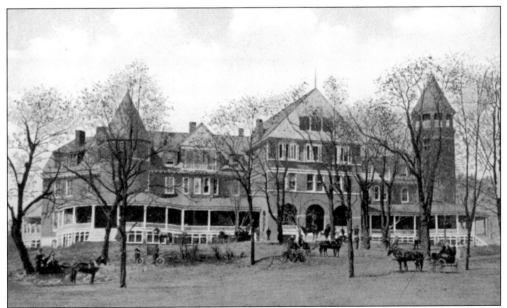

An investment company founded by John Handley and others built the Winchester Inn. The Equity Improvement Company was to raise $1 million to fund business projects. The inn would be needed as business boomed and the population grew. Unfortunately, there was a depression in the 1890s, and the boom never materialized. The company was mired in debt and neither it nor the inn survived. (Courtesy Leighanne Zeigler.)

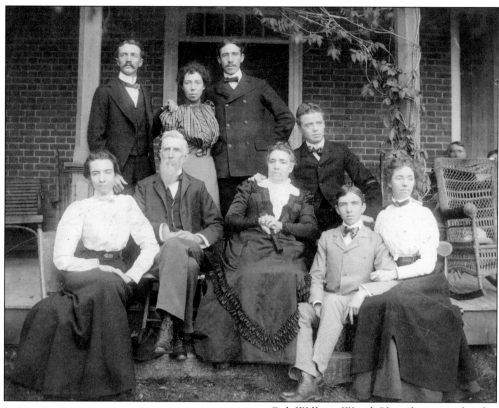

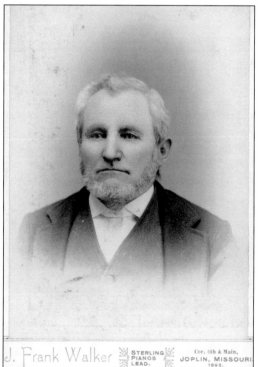

Col. William Wood Glass, his second wife, Nannie Campbell Glass (1842–1930), and their children pose at Glen Burnie c. 1895. They are, from left to right, as follows: (first row) Susan Glass (1869–1946), Col. William Wood Glass, Nannie Glass, William Wood Glass Jr. (1874–1954), Julian Wood Glass Sr., and Katherine Glass (1865–1948); (second row) Thomas R. Glass (1872–?), Harriet Wood Glass (1868–1953), and Dr. Robert Glass (1874–1964). (Courtesy Museum of Shenandoah Valley.)

John Bard Higgins was a wagon maker located as advertised in the September 30, 1857, *Winchester Republican* "at the Old Stand of my Predecessor, Frederick Schultz," which was at Washington and Piccadilly Streets. He served in Company B, 31st Regiment, Virginia Militia in 1861. Motivated by the gold rush, he went to California in 1849 and 1852. By 1874, he owned a hotel in Missouri. (J. Frank Walker, photographer; courtesy Sammy Copenhaver.)

Three

EDUCATION

During the late 19th century, the vast majority of Winchester schools were for women, and many came long distances to study. In 1854, the building at 112 South Cameron Street (shown here as the Fairfax Inn) opened as the Valley Female Institute. The goal of the institute was to provide "a thorough English, Classical and polite education." This was the site of the York Confederate Hospital. (Courtesy Stewart Bell Jr. Archives.)

The Shenandoah Valley Academy was defunct when this picture of the superintendent's residence was taken in the early 1950s. The school was a white boy's preparatory school that operated from 1865 to 1939. The school moved to this final location on Academy Circle in 1895. Before 1895, it occupied several other locations, including a local church, a home on Fairmont Avenue, and Aspen Hill. (Charles Murphy, photographer; courtesy Bill Madigan Collection.)

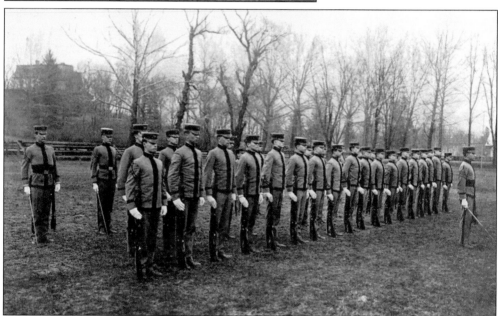

In 1906, Principal J. B. Lovett incorporated military training into the Shenandoah Valley Academy's curriculum. From 1908 to 1936, under his successor, Maj. Brantz Mayer Roszel, military training was strongly emphasized. This photograph of the school's cadet corps appeared in a 1927 chamber of commerce publication. At the start of World War I, all eligible boys and the entire faculty enlisted in the service of their country. (Courtesy Leighanne Zeigler.)

Horace McKee was a student at the school in 1926. This bill is made out to his mother, Maude McKee, for his half-year tuition and other student fees. Sometime after 1895, Principal J. B. Lovett added a gymnasium to the facility, and the charges shown here include a $10 athletic fee. In addition, Maude McKee was charged for everything from a uniform to cuffs and collars. (Courtesy Bill Madigan Collection.)

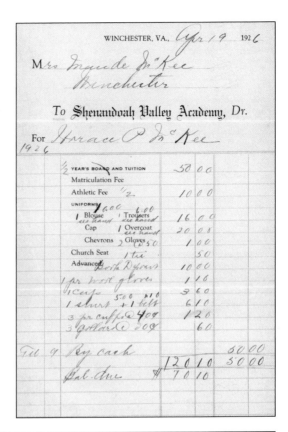

This envelope, with its 2¢ stamp, transmitted Horace McKee's school bill. McKee was a paying student at Shenandoah Valley Academy. That was not true of all students. When R. A. Robinson gave the property for the school in 1895, he specified that four scholarships per year must be provided to Winchester or Frederick County students. In 1927, the academy reached its highest enrollment at 121 students. (Courtesy Bill Madigan Collection.)

Katherine Glass Greene (1865–1948), with Laura Gold, established Fort Loudoun Seminary in 1905 and operated it until 1925. Born at Rose Hill in Frederick County, Greene authored *Winchester Virginia and its Beginnings* and *The Evolution of the Conception of God* and coauthored *Brigadier General and Governor James Wood Junior* with her brother, William Wood Glass. She was founder of the Fort Loudoun chapter of the Daughters of the American Revolution. (Courtesy Stewart Bell Jr. Archives.)

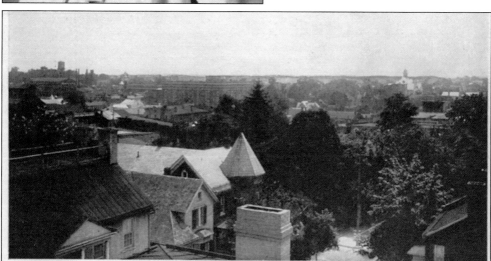

WINCHESTER, VIRGINIA, FROM FORT LOUDOUN SEMINARY. Winchester, the oldest city in America west of the Blue Ridge, became a town in 1752 by act of the House of Burgesses, and is the first namesake of Winchester, England. Until the close of the Revolution, the town was, in effect, the capital of the Northern Neck of Virginia, the domain over which Lord Fairfax exercised proprietary rights. During the Civil War it changed hands seventy-two times, six pitched battles were fought within a five-mile radius, and 200 houses in the town were destroyed. The picture above shows a section of modern Winchester.

This view of Winchester was taken from Fort Loudoun Seminary around 1924. The house in the left foreground is the John Peyton Clark house. The seminary operated from 1905 to 1925 as a women's school. Its curriculum included college preparatory or high school, two-year college courses, two-year business courses, domestic science, music, expression and physical culture, and art. Fort Loudoun Apartments now occupy the site. (Courtesy Leighanne Zeigler.)

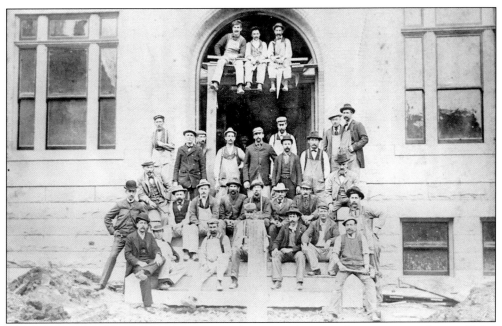

In 1883, these unidentified construction workers paused to pose for a picture in front of John Kerr School. Before the Kerr School was built, Winchester free schools had rented space in buildings throughout the city. The building being constructed here had eight classrooms when it was finished. In 1908, a six-room addition was built on the back of the school. Kerr School still stands at 201 South Cameron Street. (Courtesy *The Winchester Star*.)

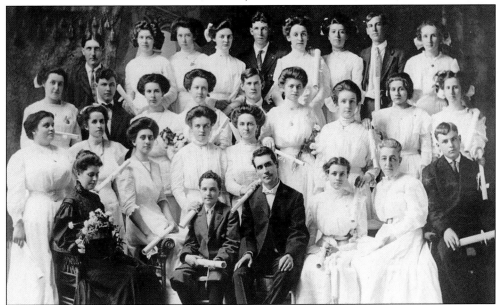

This picture shows the class of 1909 from the John Kerr School. The school was named after John Kerr, a local cabinetmaker who was born in England. In 1875, his will provided money toward a school for the education of Winchester's poor white children. This bequest, along with some city money, funded the school. It was the first gift to free education ever made in Virginia. (Courtesy *The Winchester Star*.)

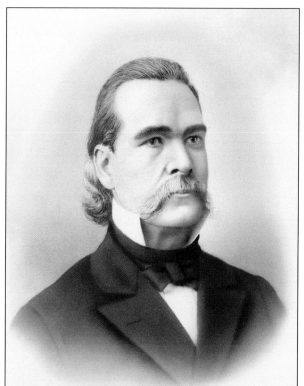

Judge John Handley (1835–1895), a penniless Irishman, immigrated to the United States in 1854. By 1874, he was a wealthy businessman elected as a judge in Scranton. He fell in love with Winchester's people and history. Maj. Holmes Conrad became his good friend and partner. Never a Winchester resident, Handley forever changed the town when he left much of his large estate for a library and public schools. (Courtesy Stewart Bell Jr. Archives.)

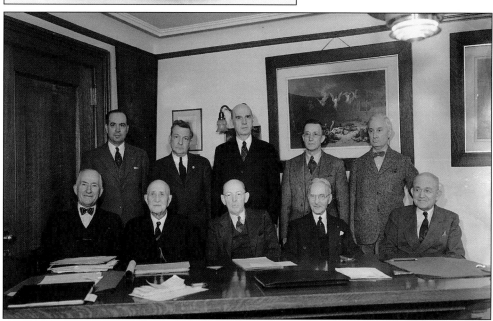

The Handley Board of Trustees on February 9, 1942 are, from left to right, as follows: (seated) John I. Sloat (1918), M. M. Lynch (1896), H. D. Fuller (1915), T. Russell Cather (1927) (president), and W. E. Cooper (1935); (standing) Clifford D. Grim (1940), W. Nelson Page (1936), Charles H. Harper (1938), Dr. George G. Snarr (1941), and C. Vernon Eddy (1920) (secretary). Date of appointment follows the name. (Courtesy Handley Board of Trustees.)

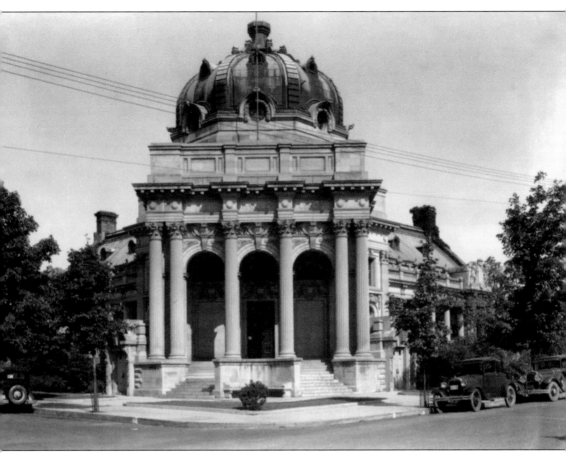

The Handley Library at 100 West Piccadilly is a public library. Judge John Handley of Scranton, Pennsylvania, bequeathed $250,000 to Winchester to be invested by its leaders. When the sum doubled, it was to be used to build a library and the balance to be endowed. Built in the Beaux-Arts architectural style, the library was constructed of Indiana limestone. The total cost to build and furnish the building was $233,230. When the library opened on August 12, 1913, it featured a lecture hall, as well as conference and study rooms. The lecture hall seated 300 and was a center for activities for many years. But the library was open to white patrons only until December 1953, when the city of Winchester passed a resolution at the request of the Winchester Council of Church Women to make the Handley Library available to all city residents regardless of race, color, or creed. Before that, blacks used a branch library, which was set up in the Douglas(s) School building in October 1921. (Lawrence Jolliffe, photographer; courtesy Stewart Bell Jr. Archives.)

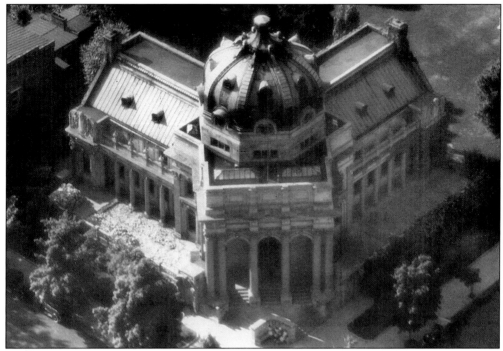

New York architects Stewart Barney and Henry Otis Chapman designed Handley Library. The 1913 building represents an open book—the dome as spine and the wings as covers. An addition was completed in 1979 by the architecture firm Smithey and Boynton of Roanoke. It won an American Institute of Architects first honor award. One jury member commented, "the new wing is like a grandson leaning against his grandfather." (Courtesy Stewart Bell Jr. Archives.)

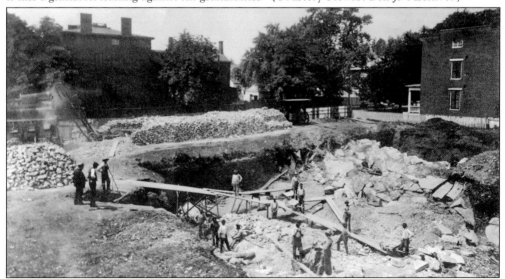

Construction on Handley Library began in March 1907. The photograph shows a view of the excavation from the northeast looking southwest. Piccadilly Street runs between the site and the three-story building at 135 North Braddock Street on the left. The building on the right is 116 West Piccadilly Street. The excavation site occupies a 180-by-250-foot lot at the corner of Braddock and Piccadilly Streets. (Courtesy Stewart Bell Jr. Archives.)

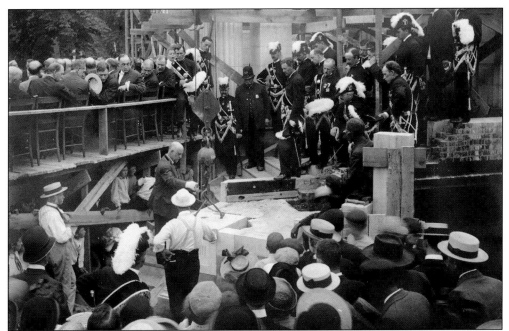

The Handley Library cornerstone was laid May 28, 1908, by Winchester Hiram Lodge, No. 21. Knights Templar, Winchester Commandery, No. 12. They appeared in plumed hats, sashes, and scabbards. Preceded by a grand parade, Grand Master Joseph W. Eggleston conducted the ceremonies above. Maj. Holmes Conrad (not in this photograph), then president of the Handley Board of Trustees, delivered the eloquent oration. (Courtesy Stewart Bell Jr. Archives.)

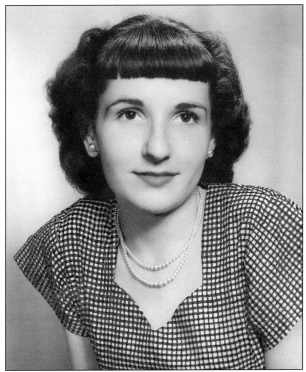

Johan T. Coates has served as secretary and treasurer of the Handley Board of Trustees since 1960. Coates became C. Vernon Eddy's secretary in 1949 after graduating from Handley High School. As she puts it, she has since "earned several degrees in hard knocks." She has held nearly every job in the library. She married Ralph E. Coates in 1951, and they had four children. (Courtesy Handley Board of Trustees.)

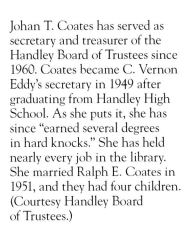

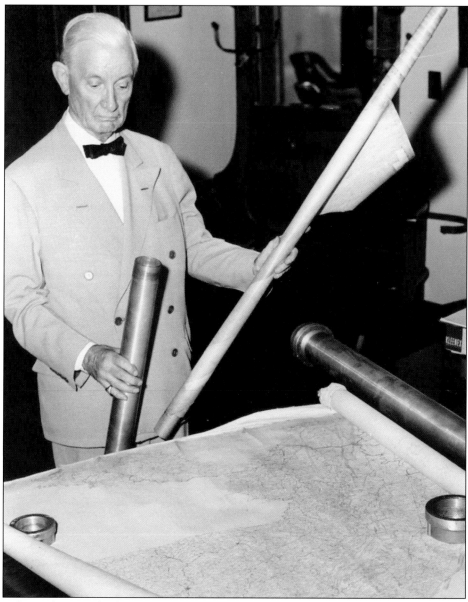

Winchester-born and educated, C. Vernon Eddy (1877–1963) was Handley's first librarian, serving from 1913 to 1960. This photograph shows how he used Alcoa aluminum tubes in 1954 to protect valuable Jedediah Hotchkiss maps used by Generals Lee, Jackson, and Early in the Civil War. At the request of the Library of Congress, Eddy searched for and found the forgotten Hotchkiss maps, most of which are now in the Library of Congress. Several are in the Stewart Bell Jr. Archives at Handley Library. Eddy was integrally involved in the community. He served as secretary (1920–1960) and treasurer (1931–1960) of the Handley Board of Trustees. He was a charter member of the Rotary Club and an officer of the Winchester Historical Society. Eddy's portrait hangs with other Virginia grand masters' portraits in the Allen E. Roberts Library and Museum at the Grand Masonic Lodge in Richmond. Eddy served as Virginia grand master. He was selected in 1948 as sovereign grand master of the Grand Council Allied Masonic Degrees of the U.S.A. (Courtesy Stewart Bell Jr. Archives.)

This is the original circulation desk in the Handley Library rotunda at 100 West Piccadilly Street in 1946. In the left background is the card catalog. Over the doorway on the right hangs a portrait of Holmes Conrad, Winchester leader and influential Washington lawyer. (Hugh G. Peters of Winchester, photographer; courtesy Stewart Bell Jr. Archives.)

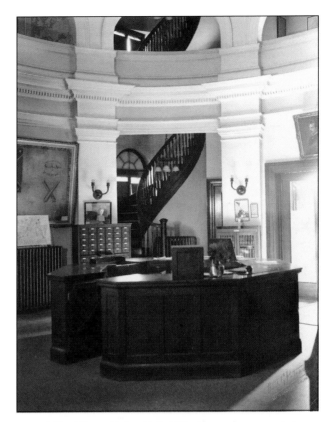

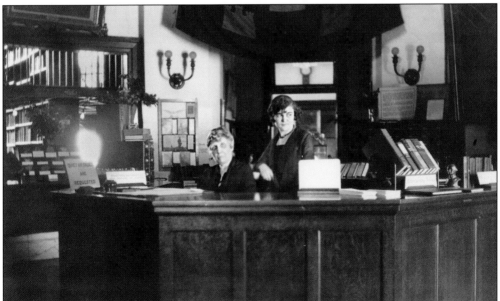

Judith C. Gibson (left) was elected assistant librarian in 1913 by the Handley Board of Trustees. They paid her an annual salary of $400. C. Vernon Eddy, librarian, was paid $1,200. Christina W. Cook (right) assisted Gibson. Gibson and Cook were waiting for patrons to check out books on a sunny day about 1925. (Courtesy Stewart Bell Jr. Archives.)

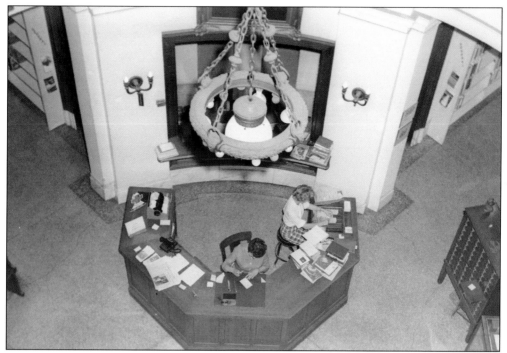

Clara B. Hyssong (left), head of circulation, and either Phyllis Feigensong or Lois Jean Wade (right) are shown in 1963 at Handley's circulation desk. Extensive renovation of Handley Library was completed in 2001. The exterior copper dome and interior stained glass were cleaned and renewed. Cables for computer networking and Internet connectivity were laid. Beautiful carpet was designed for the library. (Photo Shop, photography; courtesy *The Winchester Star*.)

The 1979 addition included a basement lobby, conference room, archives reading room, and archives storage area. Rebecca A. Ebert became the archivist and continues there today. In 2001, the archives were named for Stewart Bell Jr. and are now operated by the library and the Winchester–Frederick County Historical Society. Researchers visit from all over the world to research the history and people of the Shenandoah Valley. (Courtesy Stewart Bell Jr. Archives.)

Prof. Powell W. Gibson (1875–1959) was born in Middleburg, Virginia, in 1875. He taught in several Northern Virginia schools and was superintendent of schools in Kent County, Maryland, for three years. Named first principal of the Douglas(s) School, he served in that capacity for a quarter-century. He believed it was the duty of a teacher to inspire. Powell was also a published poet. (Courtesy Stewart Bell Jr. Archives.)

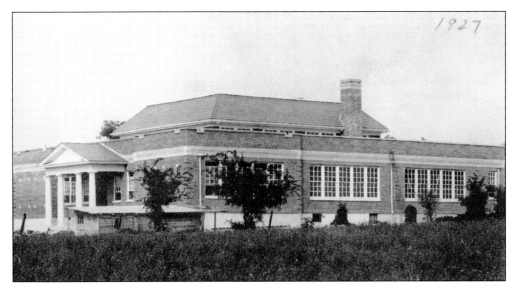

Until 1927, Winchester's African American children were educated in the cramped quarters of the old stone church at 308 East Piccadilly Street. Judge John Handley, Winchester's most important benefactor, bequeathed a sum to accumulate for 20 years and then be used for "school houses for the education of the poor." In 1927, the Handley bequest was used to build Douglas(s) School at 590 North Kent Street. (Courtesy Stewart Bell Jr. Archives.)

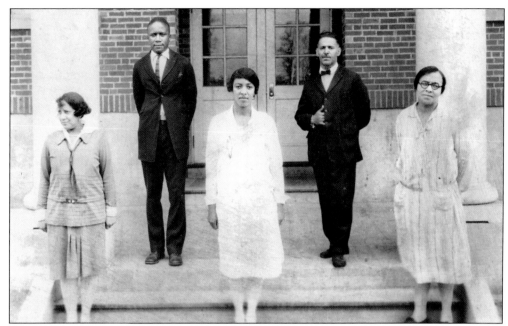

The Douglas(s) School was named after African American orator and abolitionist Frederick Douglass. This eight-classroom schoolhouse was built for Winchester's black students. Pictured here are the first faculty members. From left to right are (first row) Hattie Lea, Lovelena Lomas Marcus, and Anna Quiet Brooks Tokes; (second row) Mr. William Marcus and Prof. P. W. Gibson, principal. The Douglas(s) School is on the National Register of Historic Places. (Courtesy Stewart Bell Jr. Archives.)

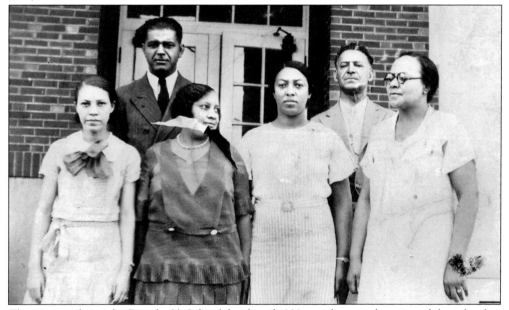

This picture shows the Douglas(s) School faculty of 1939 standing on the steps of the school at 590 North Kent Street. From left to right are (first row) Marie S. Brisco, Hattie Lea, Lovelena Lomas Marcus, and Anna Quiet Brooks Tokes; (second row) Dr. Taylor Floyd Finley Sr. and Prof. Powell W. Gibson. The school closed in 1966. (Courtesy Stewart Bell Jr. Archives.)

Pictured here is the faculty of the Douglas(s) School in 1947. Some of the individuals have been identified as (order unknown) Alma Layton, Luada Laton, Francis M. Jackson, Hattie Lea, Lovelena Lomax Marcus, Anna Brooks Tokes, Kirk Gaskins, Marcia Green Taper, Margaret Washington Parks, and Effie McKenny Davis. Two additions were made to the school—eight rooms in 1951 and five more rooms in 1963. (Courtesy Stewart Bell Jr. Archives.)

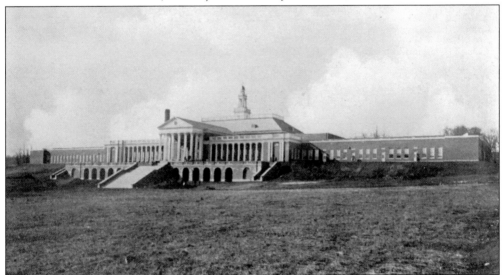

John Handley School opened in 1923 to white children, grades four through high school. Handley, built and endowed with funds from the bequest of Judge John Handley to build "school houses for the education of the poor," overlooks a 40-acre campus. A neoclassical revival building, it incorporates architectural characteristics of the University of Virginia. Now a high school, Handley is on the National Register of Historic Places. (Courtesy of Leighanne Zeigler.)

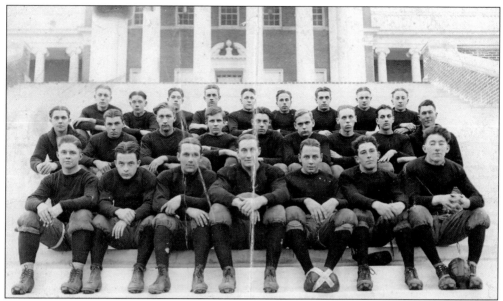

Members of Handley High's first football team in 1924 were, from left to right, as follows: (first row) Conley Anderson, Maurice Grim, George Snyder, Eldridge Poole, Chrisman Hackman, Paul Hillyard, and Robert Eagle; (second row) Herbert Lauck (coach), Otis Sargent, George Miller, Frank Ritter, Abe Zirkle, Paul Dunham, Frank Tyler, Frank Woodward, and Harry McCann; (third row) Wilbur Riley, Vincent Curl, "Dodger" Hodson, Wesley Crisman, Jim Stine, Asbury Jackson, Irvin Cather, Delmer McIlwee, and Abner Huntsbery. (Courtesy Stewart Bell Jr. Archives.)

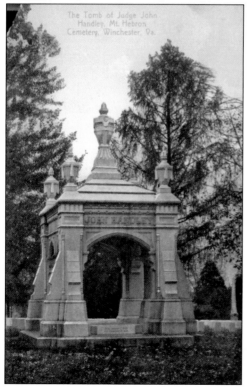

This memorial on John Handley's burial site weighs 75 tons. It is believed that he designed it himself. Judge Handley died in Scranton in 1895 and, at his request, was buried in Mount Hebron Cemetery. Due to his size (thought to be over 6 feet 6 inches tall), he was buried in a 6-foot-10-inch casket. High school students and faculty visit his grave every May to pay homage to their benefactor. (Courtesy Leighanne Zeigler.)

Four

BUSINESS

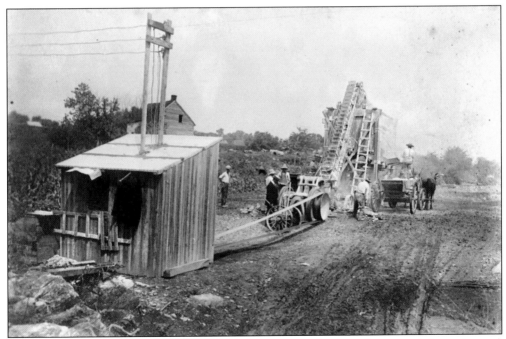

Quarrying has been a major industry in Winchester since the days when men (often prisoners) wielding 16-pound hammers broke limestone rocks. This picture shows a step up in technology, with men operating a motorized belt-driven crusher at the original crushing plant at City Quarry. The quarry was at City Works, south of Cork Street near the railroad tracks. It opened in 1917. (Courtesy Stewart Bell Jr. Archives.)

Charles Frederick Barr (1870–1945), known as C. Fred Barr, was Winchester's leading photographer. He had a good sense of humor, too, and is perhaps showing it in this pose. For over 40 years, Barr worked in his studio at 118 North Loudoun (Main) Street on the second floor of the Masonic Temple. He took an early interest in cameras, and after finishing school, he associated himself with local photographer Dr. James B. Wortham. In 1889, when Wortham died, Barr purchased his photography business. Barr received many national and state awards for his work. He took a keen interest in community affairs as a member of Hiram Lodge No. 21 A.F. and A.M., Rouss Fire Company, and Winchester Rotary Club. He was known as a noble, courteous, and kind man. He was married to the former Mary Wall of Winchester. Barr died at age 75 in his home at 221 West Boscawen Street and was buried in Mount Hebron Cemetery. (Courtesy Stewart Bell Jr. Archives.)

C. Fred Barr's humor shows in this advertisement he used in 1927. A native of Winchester, Barr operated one of the outstanding studios in the Valley of Virginia for 57 years. His daughter Elizabeth Barr and family friend Helen Reardon continued to run the business on Loudoun Street until the 1970s. (Courtesy Leighanne Zeigler.)

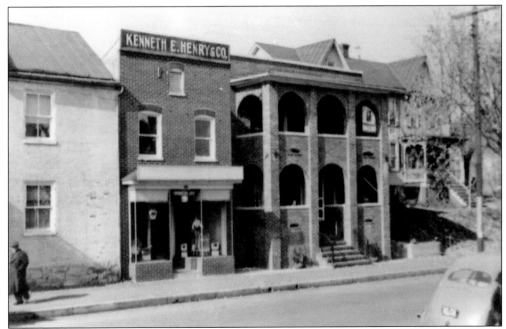

Kenneth E. Henry and Company, at 127 South Braddock Street, was the oldest typewriter business in town. Henry (1907–1989) operated the business from 1932 to 1985, when he and his wife Edith (Spaid) Henry (1909–2004) retired. Before typewriters, Henry ran a radio shop at 2 South Loudoun Street. Henry later ran a stamp-collecting business out of his home at 320 South Loudoun Street in the old E. L. Henry home. (Courtesy Ben Ritter.)

Bailey's Store was located at 4 South Cameron Street on the southeast corner of Cameron and Boscawen Streets. The picture was taken in 1938. Local historian William Greenway Russell remembered that this property was converted into a service station in 1953. Ora Bailey must have done well because, between 1944 and 1963, he owned the Lawrey House, a substantial stone dwelling at 409 South Braddock Street. (Courtesy Ben Ritter.)

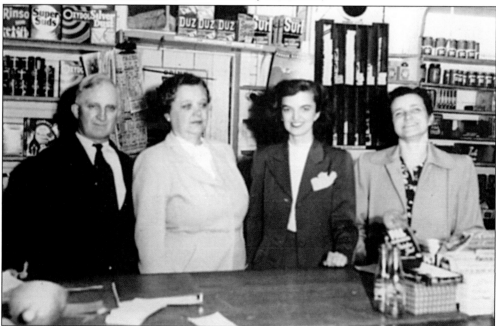

Ora Bailey stands proudly behind the counter of his store with Mae Bailey, Isabelle Bailey Hickman, and Helen Lutz. Some of the products on the shelves are sold in stores today. Others belong to the past. The products shown here include Rinso, Super Suds, Oxydol, Silver Dust, Vel, Duz, Kix, and Cheerios. (Courtesy Ben Ritter.)

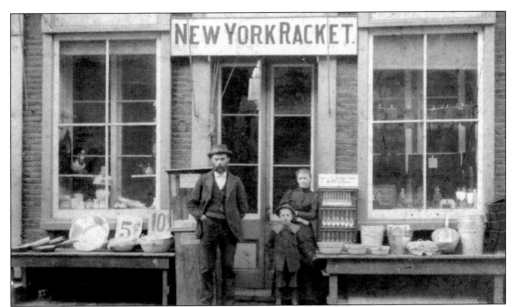

The owner of the New York Racket, John W. Nail (left), stood in front of the store at 141 North Loudoun Street with his wife, Julia Pingley Nail, and son, Frederick Grady "Tac" Nail, around 1900. Nail began this mercantile business in 1884 with very little. Eventually, the stock became worth several thousand dollars. Nail was also known throughout the city and county as a talented wood carver. (Courtesy Clark Nail.)

In 1914, Octavia Jack and her husband, Charles, built the 3-story, 39-room Hotel Jack at Piccadilly Street and Indian Alley. Wachovia bank's drive-up window is there now. It was considered the best hotel in town until the George Washington Hotel was built in 1924. The Jack was demolished in 1955 to build a parking lot. Its columns are now part of Fort Loudoun Apartments. (Courtesy Leighanne Zeigler.)

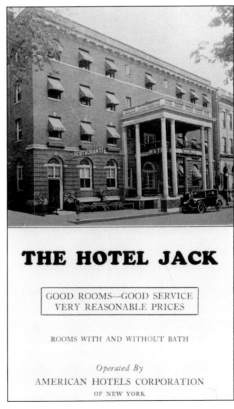

THE HOTEL JACK

GOOD ROOMS—GOOD SERVICE
VERY REASONABLE PRICES

ROOMS WITH AND WITHOUT BATH

Operated By
AMERICAN HOTELS CORPORATION
OF NEW YORK

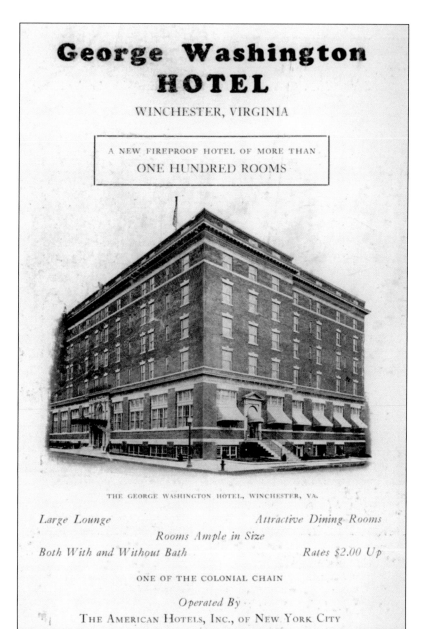

George Washington
HOTEL
WINCHESTER, VIRGINIA

A NEW FIREPROOF HOTEL OF MORE THAN
ONE HUNDRED ROOMS

THE GEORGE WASHINGTON HOTEL, WINCHESTER, VA.

Large Lounge *Attractive Dining Rooms*
Rooms Ample in Size
Both With and Without Bath *Rates $2.00 Up*

ONE OF THE COLONIAL CHAIN

Operated By
THE AMERICAN HOTELS, INC., OF NEW YORK CITY

The grand dame of downtown Winchester was the George Washington Hotel, which was built for $600,000 and opened in 1924. It featured 102 rooms, a large dining room, a ballroom, and a barber shop. It was operated by the American Hotels Corporation, which managed 25 other hotels in the country. Winchester citizens held banquets and balls in this building. The hotel was always the center of the Shenandoah Apple Blossom festivals. After several plans to renovate the hotel fell through, GW Development LLC purchased it and made a multimillion-dollar agreement with Wyndham International, Inc., which operates 10 other historic hotels in the country. Slated to reopen soon, the George Washington Hotel will be full service, housing 90 rooms (including 10 suites), an indoor pool, a fitness center with spa treatment rooms, an open grill restaurant with alfresco dining, a lobby bar with fireplace and piano, and a 5,000-square-foot ballroom/high-tech meeting area. (Courtesy Leighanne Zeigler.)

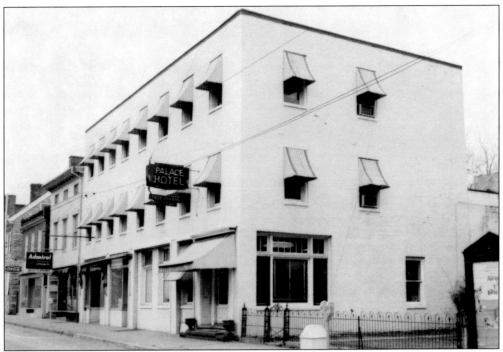

The Palace Hotel, at 103 South Loudoun Street, was convenient to the courthouse and downtown businesses. In 1940, G. E. McCormick was the proprietor. The hotel advertised a free rear parking lot. The Palace Hotel burned down in the early 1950s, and today a parking lot is there in its stead. The iron fence in the foreground surrounds Wisteria House, which is still there today. (Courtesy *The Winchester Star.*)

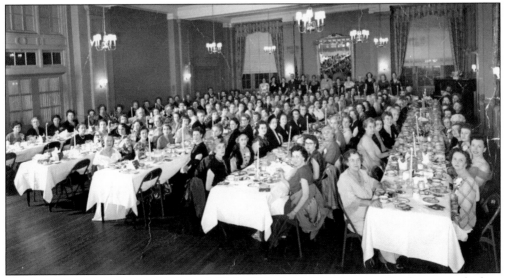

The Business and Professional Women's Club of Virginia's Fall Planning Conference took place at the George Washington Hotel in September 1949. Chartered on April 21, 1947, two of the club's purposes were to elevate the standards of women in business and to extend opportunities to women in industrial, scientific, and vocational activities. Charter members of the Winchester club are included in this picture. (Courtesy of Stewart Bell Jr. Archives.)

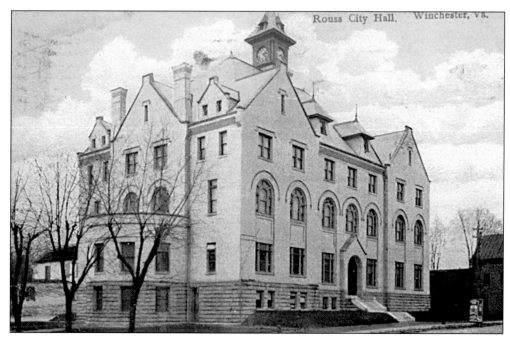

Before Rouss City Hall opened in 1901, city courts met in the Frederick County Courthouse. City officials were scattered in various rented properties. Charles Rouss donated $30,000 toward the building, provided that the city added $10,000. The market house was torn down to make room for the city hall, which stands at the corner of Cameron and Boscawen Streets. The building included a Masonic lodge and performance auditorium. (Courtesy Leighanne Zeigler.)

The Winchester Railroad Station still stands at Piccadilly and Kent Streets and is still being used by the railroad companies today. Winchester and Western Railroad operates out of the upper floor, while some crew operations for CSX Railroad are conducted on the ground floor. (Courtesy Diane Berry, photographer.)

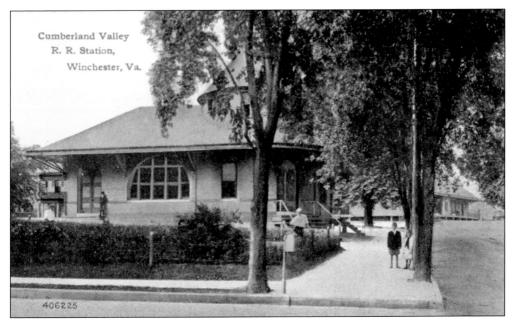

Cumberland Valley Railroad Station at 305 West Boscawen (Water) Street, on the corner of South Stewart and West Boscawen Streets, was conveniently located for the students of the Shenandoah Valley Academy and their visiting families. This photograph is looking west. The railroad station was demolished about 1937. The Winchester Little Theatre is located today in the Cumberland Railroad Freight Station nearby at 315 West Boscawen Street. (Courtesy Leighanne Zeigler.)

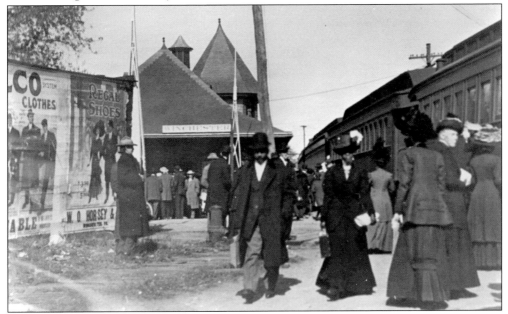

The Winchester Baltimore and Ohio (B&O) Railroad Passenger Station is located at the corner of Piccadilly and Kent Streets. This east-west line was built in the late 1890s. The B&O track was old and worn by the end of the Civil War because of damages inflicted by either side to delay armies. When B&O submitted war claims to the U.S. government, the company was reimbursed millions of dollars. (Courtesy Leighanne Zeigler.)

WHITE HOUSE

APPLE SAUCE

APPLES, SUGAR AND WATER

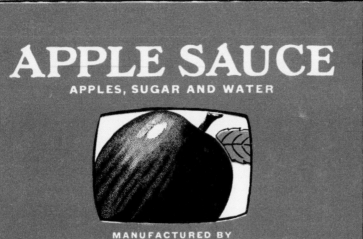

MANUFACTURED BY
NATIONAL FRUIT PRODUCT COMPANY, INC.

WHITE HOUSE
FOOD
PRODUCTS
—
Apple Sauce

Apple Jelly

Apple Butter

Canned Apples

Apple Juice

Fruit Pectin

Vinegar

Prune Juice

This White House Apple Sauce (a National Fruit Product brand) label underwent a change in 1953, when the apple was placed outside the frame and the product name moved to the inside. In 1990, the label was changed again to include photographs of apples, giving a fresher, more nutritious look. At the time of this writing, in 2006, a local investment company is planning to purchase the company and label. (Courtesy Stewart Bell Jr. Archives.)

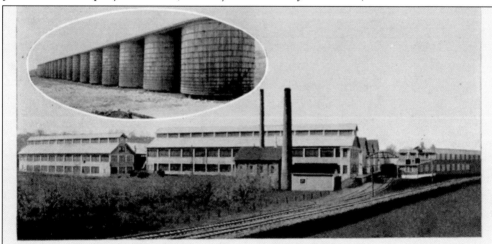

NATIONAL FRUIT PRODUCT COMPANY, INC. PLANT, WINCHESTER, VA., located in the heart of the Shenandoah Valley apple belt. It is the largest of its kind in the world. It produces 2,500,000 gallons of cider and vinegar per annum, 300,000 cases of canned apples, apple sauce and apple butter, and 1,000 tons of apple pulp. These products are shipped to every state in the Union east of the Mississippi River, and to many beyond. Twenty of the eighty 27,500-gallon capacity vinegar tanks are shown in the insert. The company operates other plants at Alexandria, Va., Waynesboro, Va., and Martinsburg, W. Va.

National Fruit opened its first facility, a vinegar plant, in Winchester in 1915. This postcard picture shows the National Fruit Product Company plant at 550 North Fairmont Avenue. Superimposed at the top of the photograph is a picture of twenty of the eighty 27,500-gallon vinegar tanks at the plant. This was the largest apple processing plant in the world. (Courtesy Leighanne Zeigler.)

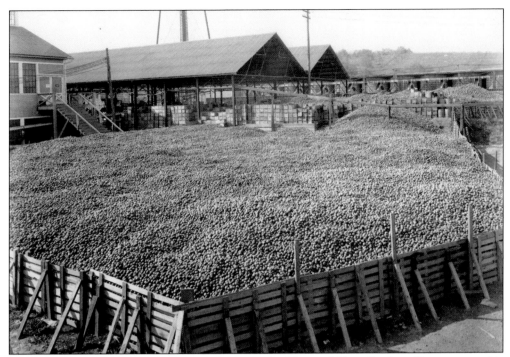

Apples, apples, and more apples waited outside the National Fruit Product Company in this *c.* 1930 photograph by C. Fred Barr. They were eventually conveyed inside the plant, where they were graded, sorted, washed, and processed. The conveyor belt, storage crates, and vinegar vats can be seen in the background. In 1982, production reached a record of 4.7 million bushels of apples. (Courtesy Stewart Bell Jr. Archives.)

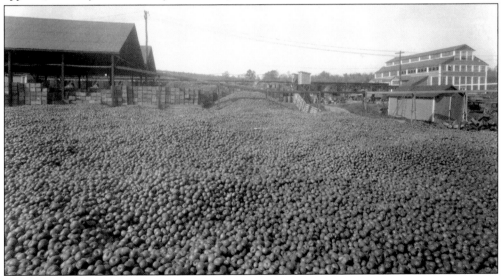

The apple harvest shown here in 1925 is emblematic of the long-standing importance of this crop to Winchester. Lord Fairfax stipulated that, after 1748, all grants from his property must contain at least 100 apple trees. It is believed that Benjamin Franklin introduced apples from the Shenandoah Valley to the British court. Dr. John Lupton planted the first commercial orchard in the mid-19th century. (Courtesy Stewart Bell Jr. Archives.)

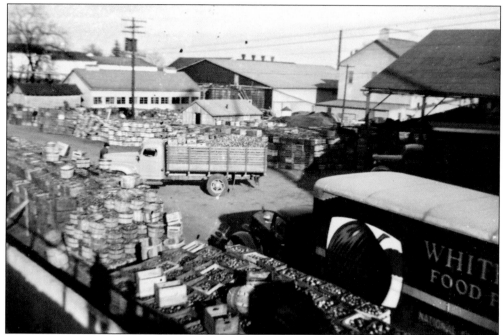

This 1955 photograph of the west side of Fairmont Avenue shows the apple crop being delivered by truck to the National Fruit Product Company. Visible in the foreground are some of the thousands of bushels and crates from earlier deliveries. The railroads also played an important role in the industry. They were used to carry apple products to market all across the country. (Courtesy Stewart Bell Jr. Archives.)

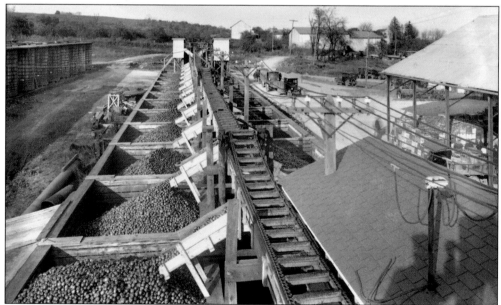

These apples were being processed along a grading belt outside the National Fruit Product Company on Fairmont Avenue. Inside, the apples were further sorted by hand. They were used to make many products, including canned apples, applesauce, juice, jelly, cider, and vinegar. The photograph was taken by C. Fred Barr about 1926. (Courtesy Stewart Bell Jr. Archives.)

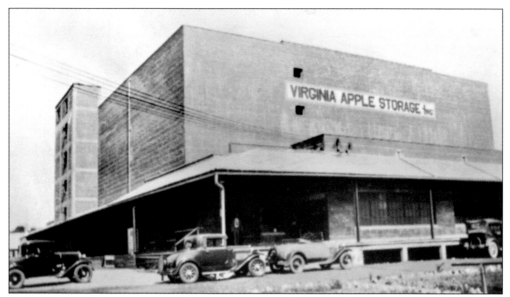

Until 1916, Winchester's apple industry was a seasonal business. In that year, Winchester Cold Storage built the largest cold-storage facility in the world. Ample cold storage allowed apples to be processed year-round. By 1918, National Fruit began to produce fruit products in addition to vinegar. Shown in this picture is the Virginia Apple Storage facility. (Courtesy Ben Ritter.)

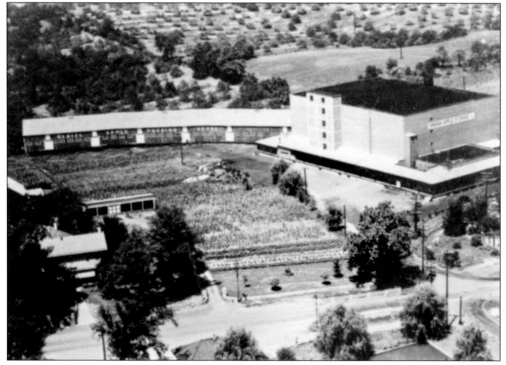

This 1947 photograph is an aerial view of the Virginia Apple Storage facility. It was located on Valley Pike across from O'Sullivan Corporation. The size of the facility is apparent from this viewpoint. A large orchard is visible behind the cold-storage building. Also visible in the photograph is the Elm's Inn, at left. (Courtesy Ben Ritter.)

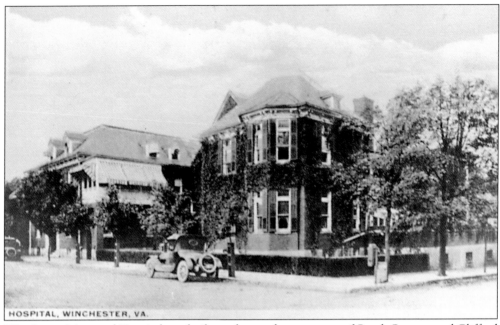

HOSPITAL, WINCHESTER, VA.

Winchester Memorial Hospital was built on the northwest corner of South Stewart and Clifford Streets for $15,000. It opened in 1903 with 12 private rooms and 24 ward beds. The school of nursing was established at the time the hospital opened. A fire in 1924 destroyed some of the original building. This photograph was probably taken after the 1930s. (Courtesy Winchester Medical Center.)

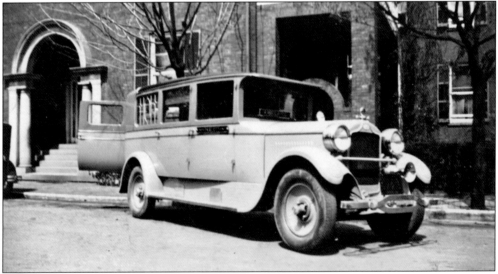

This ambulance sat in front of the Clifford Street entrance of Winchester Memorial Hospital in the 1920s. The beautiful entryway arch was reconstructed in the courtyard of the medical center on Amherst Street. Today's medical center is a major regional facility, due in part to a 1930s decision for all attending physicians to be board certified. This was rare for a community hospital at that time. (Courtesy Winchester Medical Center.)

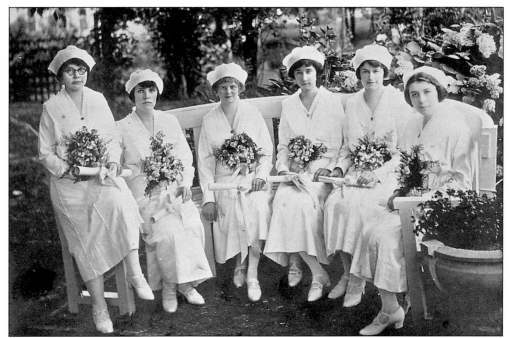

The members of the nursing school's class of 1924 are, from left to right, Katherine Booth, Esther Houseknecht, Lora Holland, Margaret Cadwallader, Grace Barrick, and Grace Walsh. The school cap was designed by Charlotte Claybrook (McGuire), RN, the first hospital and school superintendent. The school pin, a red cross in a gold wreath circle, read (translated from Latin) "faultless hands and a pure heart." (Courtesy Winchester Medical Center.)

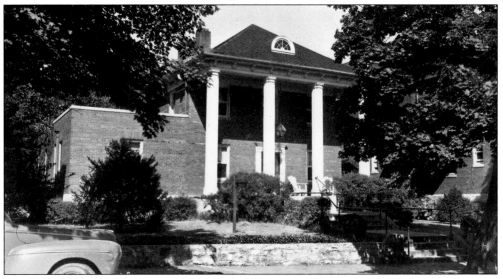

The 1927 Stewart Street entrance was used as the hospital's main entrance for over 20 years. Inside this entrance were the reception area and the administrative offices, where the switchboard and Dr. Hunter McGuire's offices were located. The Stewart Street portion of the hospital was torn down in 1948 and replaced with a five-story addition. This addition made Winchester Memorial Hospital Virginia's second largest community-owned hospital. (Courtesy Winchester Medical Center.)

Hazel Evans Foreman, RN, (1902–1981) graduated from Winchester Memorial Hospital nursing school in 1928. It was a three-year program, but after two years, her grades were so high she took her state board examinations and became a registered nurse a year early. She worked at the hospital for 53 years. After World War II, she became the supervisor of obstetrics and surgical nursing. In 1960, she became the hospital's evening supervisor in charge of surgery, the emergency room, and the psychiatric floor. She was so loved and admired that, at her 1978 retirement, she was recognized by local, state, and national leaders, and her story was carried by radio commentator Paul Harvey on his broadcast. Foreman continued part time at the hospital and in private-duty nursing until the day she died. Foreman was a wife and mother, and is has been said that she was a nurse's nurse who never met a stranger. The Winchester Medical Center has dedicated a nursing scholarship in her memory. (Courtesy Michael M. Foreman.)

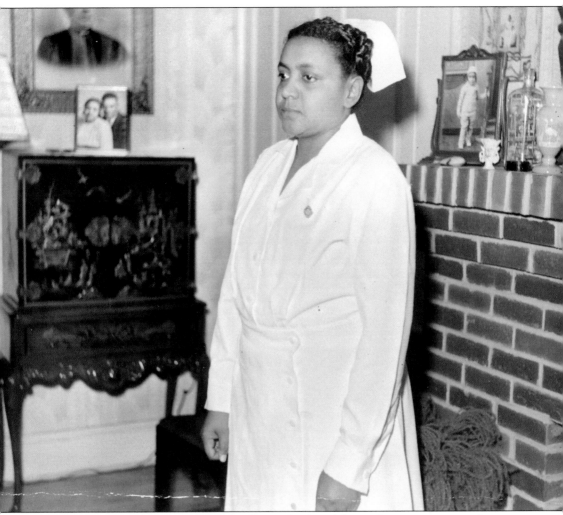

Helen Jennings Cartwright, RN, (1909–1986) was the first African American registered nurse at Winchester Memorial Hospital. Born in Winchester, Cartwright attended Douglas(s) School. Because high school was not available to African American teenagers in Winchester, she traveled to Harpers Ferry to attend Storer College. She studied nursing in New York and worked for 18 years at the Bronx Army Hospital. Later she returned to Winchester to perform private-duty nursing. In 1958, she began working for Winchester Memorial. She set up two surgical departments and was head nurse of one of them. Cartwright retired in 1974, after 44 years of service in nursing. She was a wife and a mother and was very active in the community. She served on the boards of several charities and operated the clinic at the Migrant Labor Camp. Cartwright was also on the board of trustees for United Methodist Children's Home in Richmond and was the treasurer of District 12 Virginia State Nurses Association. (Ellsworth Turner Collection; courtesy Stewart Bell Jr. Archives.)

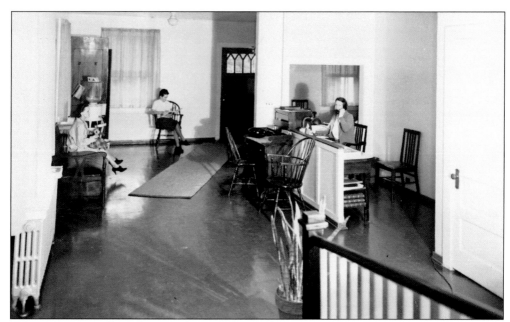

When patients walked through the 1927 hospital entrance, this reception area was the first room they saw. Frances Page was the switchboard operator for over 30 years, beginning in the 1930s. In 1946, Supt. Homer Alberti had his office here. Alberti became the hospital's executive administrator. (Courtesy Winchester Medical Center.)

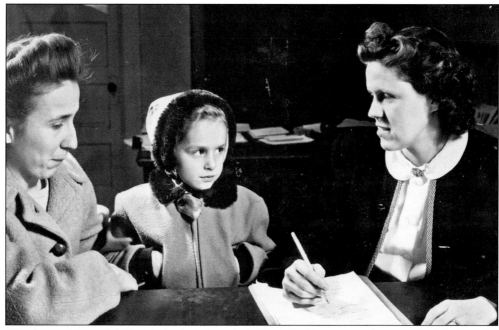

Winchester Memorial Hospital admitting clerk Virginia Gaunt was photographed during the 1948–1951 fund drive. This was one of many photographs of hospital personnel displayed in store windows to publicize the building campaign. Gaunt became head of admitting in 1957; retired in 1985, after 38 years of service; and still lives in Winchester in 2006. (William M. Rittase, photographer; courtesy Winchester Medical Center.)

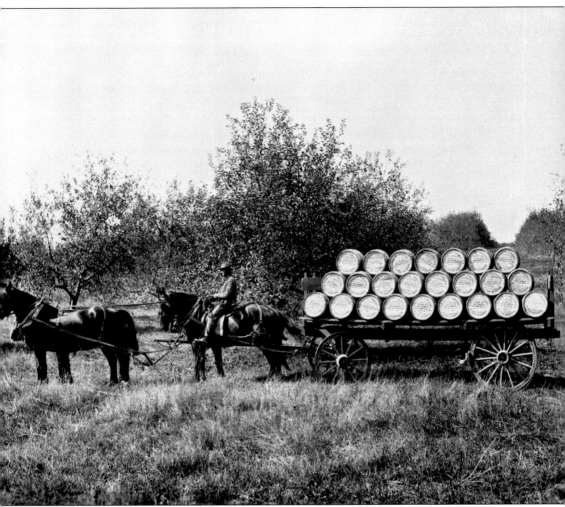

This 94-acre orchard was sold for $1.25 million in 1983 to Winchester Medical Center to build an $80-million hospital complex, which opened in 1990. This orchard belonged to Virginia Ensminger Steck de Grange and H. Clay de Grange and produced prize-winning apples. These barrels were full of apples ready for market. Each barrel read "Valley of Virginia—Standard—Grade No. 1—Ben Davis—Winchester, VA—H. Clay de Grange." De Grange was the grower and packer. Ben Davis is a variety of apple that is no longer grown. After Clay died in 1956, Virginia successfully operated the orchard until her death in 1965. A landscaped area called de Grange Orchard Park was created just inside the main entrance of the Winchester Medical Center. It was dedicated in 1991 in memory of the de Granges by their daughter, Eleanor de Grange Heath, who donated the funding for the park. This natural retreat was given by Heath to provide a place of peaceful refuge for families and staff. (Courtesy Winchester Medical Center.)

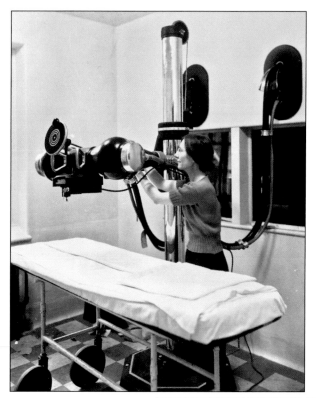

Dr. Frances Ford, the first radiotherapist at Winchester Memorial Hospital, came to the hospital from the Mayo Clinic, where she had been head of radiotherapy. This photograph, taken about 1948, shows Ford preparing an X-ray unit used for treating deep-seated tumors. She was the first full-time female doctor at the hospital. The X-ray department was established in 1933. (Courtesy Winchester Medical Center.)

This is the 411-bed Winchester Medical Center complex at 1840 Amherst Street in 2006. A nonprofit regional referral hospital, it offers diagnostic, medical, surgical, rehabilitation, and wellness services to Virginia, West Virginia, and Maryland. The hospital is noted for its Level II trauma center, neonatal-intensive-care unit, and comprehensive heart and vascular center. (Courtesy Winchester Medical Center.)

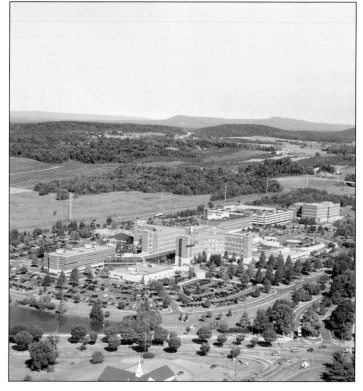

Five

LIFE IN WINCHESTER

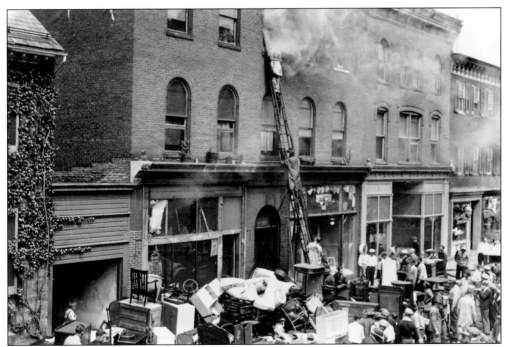

A fire broke out at the Fair Play Store and the Winchester Furniture Company at 7–15 Loudoun (Main) Street about 1934. In this photograph, smoke pours out of a third story window, while Rouss firefighters work to put it out. All the buildings in this picture are still standing. Kurtz House is in foreground. The next door down from the fire is Wilkins Shoe Store today. (Barr's Studio; courtesy Bill Madigan Collection.)

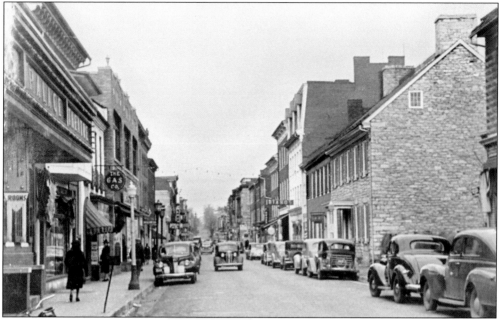

This 1940 view of South Loudoun Street was taken looking north. The street was in the original plan for Frederick Town (Winchester) and was named for a British military officer. In the left foreground is the Palace Theatre, near the gas company. Lucy Kurtz lived in the large stone home at 21 South Loudoun Street (right). Montgomery Ward was a few doors down (left background). The large stone building (right foreground) at 28 South Loudoun Street was the Godfrey Miller home (still standing). (Courtesy Leighanne Zeigler.)

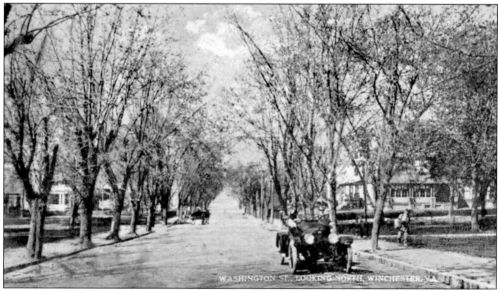

This early photograph of Washington Street looking north shows a transitional period in Winchester. For a time, automobiles and horse-drawn vehicles shared the city roads. This street was one of the original streets in the James Wood addition of 1758 and was probably named by Wood, who was a good friend of Washington. This street always has been lined with beautiful homes. (Courtesy Leighanne Zeigler.)

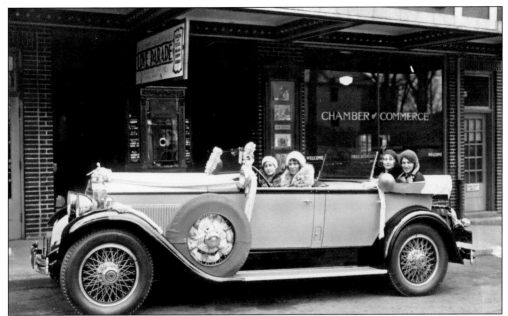

Four young women celebrate Shenandoah Apple Blossom Festival in front of the Capitol Theatre. They are riding in a brand new 1929 Packard Phaeton. Edna Lamb of Winchester is driving. Nancy Burgess Simpson of Front Royal sits in back behind the front passenger. The movie showing at the Capitol was *Love Parade*, which came out in 1929 and starred Jeanette MacDonald. (C. Fred Barr, photographer; courtesy Stewart Bell Jr. Archives.)

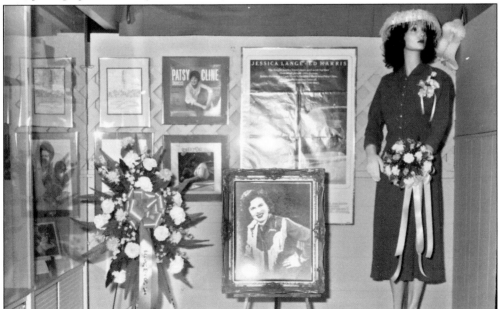

William "Bill" Madigan operated Madigan's Movie Museum at 16 South Loudoun Street during the 1980s. This window was decorated and dedicated to Patsy Cline. The museum gave tours and exhibited costumes that were worn by movie stars, including the dress Judy Garland wore in *The Good Old Summer Time* and the red military coat Nelson Eddy wore in *The Chocolate Soldier*. (Courtesy Bill Madigan Collection.)

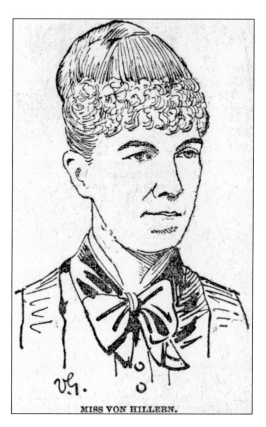

MISS VON HILLERN.

Bertha Von Hillern was an amazingly fast speed and endurance walker. In the 1870s, America went crazy, and crowds of thousands gathered to see this "pedestrienne" compete strategically. From a multi-day walk, she would earn more money than most Americans would see in two years. She retired to the Winchester–Frederick County area to paint and became a successful artist. Harry Hall's book about pedestriennes is forthcoming. (Courtesy New York Public Library.)

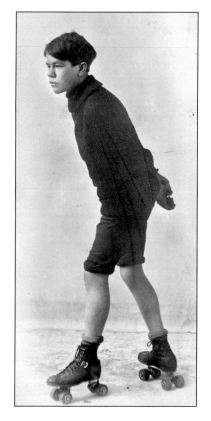

At the beginning of the 20th century, Winchester's ordinary citizens found time to play. Active hobbies, such as bicycling and roller-skating, became enormous fads. In 1907, the opening of a roller rink drew 225 skaters, as well as an audience of over 900 people. Shown here is Roy O'Rear skating, probably at the Market Street Rink. (Harry Dunn Collection; courtesy Stewart Bell Jr. Archives.)

As Winchester grew, it could support businesses aimed solely at entertainment. The Market Street Rink and Bowling Parlour was located on Cameron Street and had changed its name from Henry Brothers Rink. Market Street Rink later became the Empire Skating Rink. The Empire Rink eventually showed movies. All of these businesses occupied this space between 1908 and 1912. The building burned down in 1912. (Courtesy Stewart Bell Jr. Archives.)

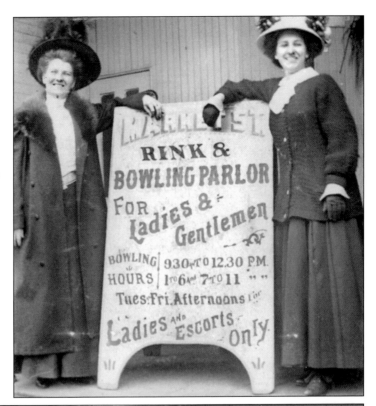

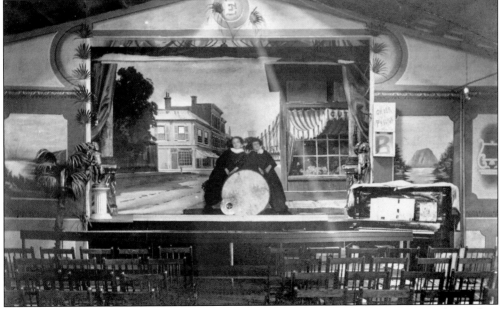

This is the interior of the Empire Skating Rink on Cameron Street. Center stage was located on the north side of the auditorium, where they sometimes ran silent movies. This was a one-story wooden building. The building burned down in 1912. Before the first skating rink was built on the site, C. J. Jacob's Coal Yard occupied the land. (Harry Dunn Collection; courtesy Stewart Bell Jr. Archives.)

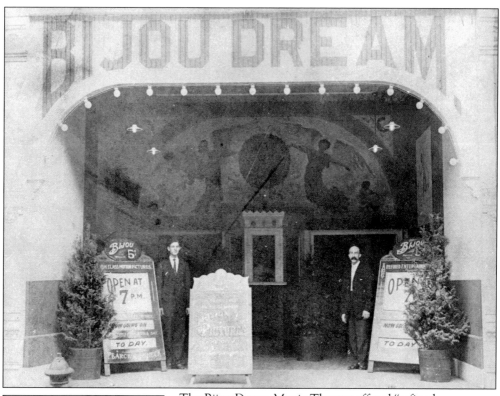

The Bijou Dream Movie Theatre offered "refined entertainment" for the cost of one nickel. The theatre was located at 148 North Loudoun Street in about 1907 or 1908. From left to right are James Spencer Ritter, grandfather of local historian Ben Ritter; Miss Fansler (center ticket booth); and theatre manager "Dutch" Collins. (Courtesy Ben Ritter; Bill Madigan Collection.)

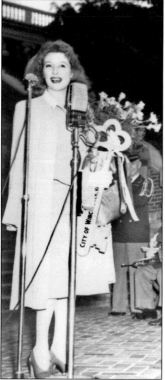

Greer Garson visited Winchester on September 8, 1942, to lead a war-bond drive. Bonds were sold for $100 each. Mrs. B. B. Dutton, head of the official welcoming committee, accompanied Garson to the Handley High School esplanade. Garson accepted flowers and the key to Winchester from Mayor Charles R. Anderson. Admission to the mammoth rally that followed was the purchase of a 50¢ war stamp. (Bill Madigan Collection.)

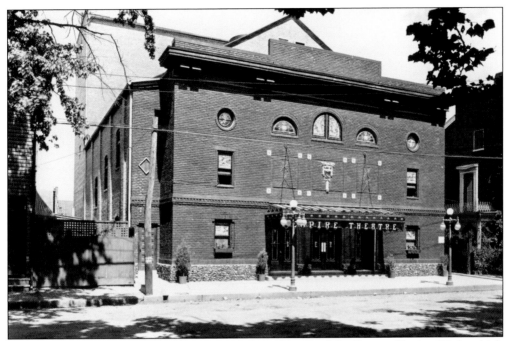

The Empire Theatre was built of brick in 1913 on the site of the Empire Skating Rink, which burned the previous year. In 1928, the Empire Theatre became the Capitol Theatre. An addition was built, and the new entrance opened onto Rouss Avenue (on the left). The Capitol Theatre seated 966 people. It was a Warner Brothers Class A theatre. (Courtesy *The Winchester Star.*)

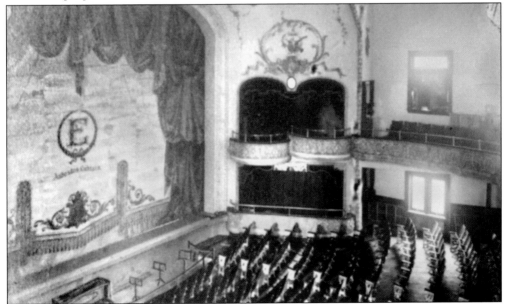

The new Empire Theatre interior was lovely, with elaborate wall ornamentation, a balcony in the back, and box seats flanking the stage. The original curtain had an "E" for Empire positioned in the center. The new Empire was the only theatre in Winchester designed by a theatre architect. This Empire Theatre auditorium became the auditorium for the new Capitol Theatre in 1928. (Courtesy Ben Ritter.)

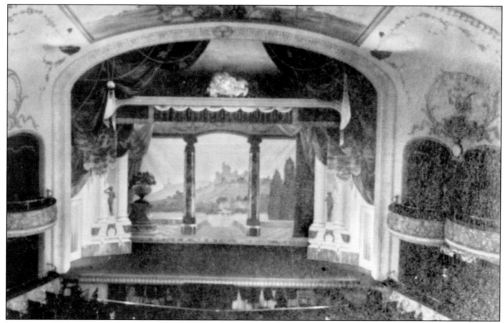

A copy of a famous engraving decorated the Empire Theatre ceiling in front of the stage. *The People of Winchester Appealing to George Washington for Protection Against the Indians* first appeared in Washington Irving's *Life of Washington* (1859). It was taken down before the theater was demolished in the 1960s. That same engraving is now displayed in the Feltner Museum on Loudoun Mall. A photograph of this engraving hangs in Handley Library. (Kenneth Henry, photographer; courtesy Ben Ritter.)

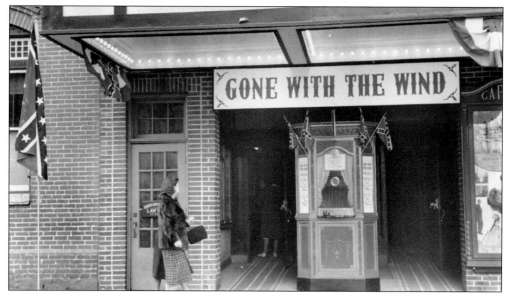

Although *Gone with the Wind* was released in December 1939, it didn't get to Winchester's Capitol Theatre until February 1940. Winchester, the site of three major battles, has always been fascinated with the Civil War era. The city recently provided shooting locations for the Civil War film *Gods and Generals*. (Arthur Rothstein, photographer; courtesy Historical American Building Survey, WPA, Library of Congress; Bill Madigan Collection.)

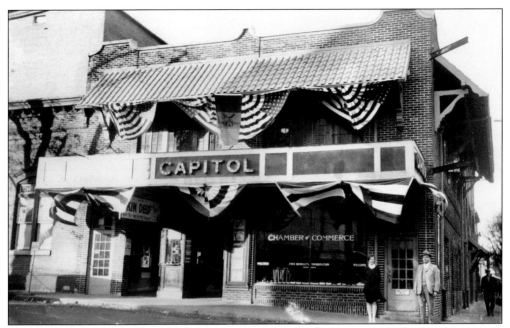

The movie showing at the Capitol Theatre was *Skin Deep*, which came out in 1929. The ad for coming attractions was for the 1929 movie *Two Weeks Off.* Andy Bell of the chamber of commerce stood outside the chamber for this photograph. The Capitol Theatre opened on December 6, 1928, and it closed in November 1965. It was demolished in 1966. (Courtesy Bill Madigan Collection.)

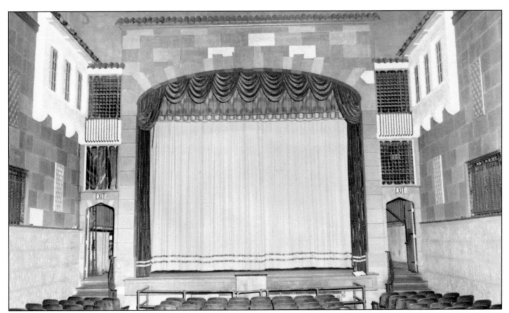

The Palace Theatre, shown c. 1940, stood at 45 South Loudoun Street. This picture shows the stage. The theatre was a beautiful place. Twinkle lights were placed in the ceiling to make it look like the sky at night, but the ceiling burned in 1934. The theatre itself burned down on November 20, 1969. This site has become a parking lot. (George Scheder, photographer; Bill Madigan Collection.)

This building at 8 West Cork Street was completed in the 1830s. It was occupied by several businesses prior to 1932, when John Hockman and William Warrick opened the Rustic Tavern, a small beer parlor. In the mid-1970s, it became the Colonial Inn. The building opened as the Cork Street Tavern in 1985 and continues to be a popular Winchester gathering place with that name. (Courtesy Cork Street Tavern.)

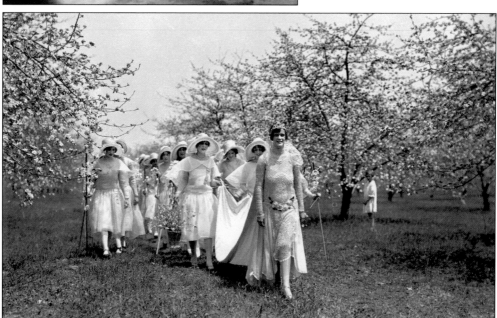

The 1928 Shenandoah Apple Blossom Festival Queen, Mary Wise Boxley of Roanoke, and her court of princesses tour an apple orchard, inspecting the blossoms that made this festival so famous. A child watches from a few feet away. The festival was started in 1924 and has attracted thousands of people from all over the world. Explorer Richard E. Byrd was the minister of crown that year. (Bill Madigan Collection.)

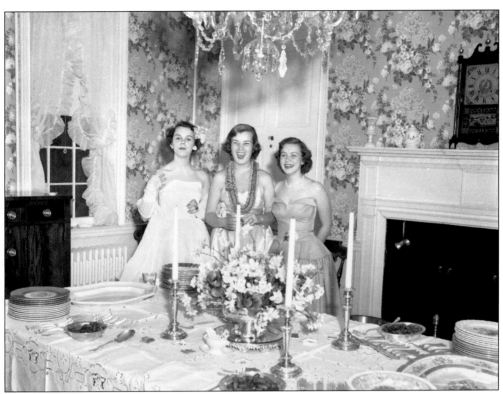

Queen Shenandoah XXIII Anne Carleton Hadley (center) is accompanied by maids of honor Elizabeth Harrison Baker of Winchester (right) and Dorothy Loane Minnigerode also of Winchester (left) at the 1950 Apple Blossom festivities. The formal table setting was located in the dining room of the 18th-century house named Rose Hill Farm, on Featherbed Lane. (Barr Studio, photographer; courtesy Bill Madigan Collection.)

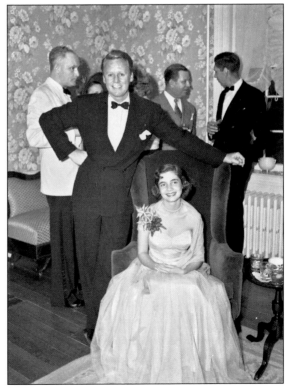

Famous actor Van Johnson, grand marshal of the 1950 Apple Blossom Parade, appeared with the queen's court at Rose Hill Farm. Anne Carleton Hadley reigned as queen of the Apple Blossom Festival that year. The man standing near the radiator is Stewart Bell Jr. During the Civil War, this home was used as a military headquarters for the Confederate and Union sides. (Barr Studio, photographer; courtesy Bill Madigan Collection.)

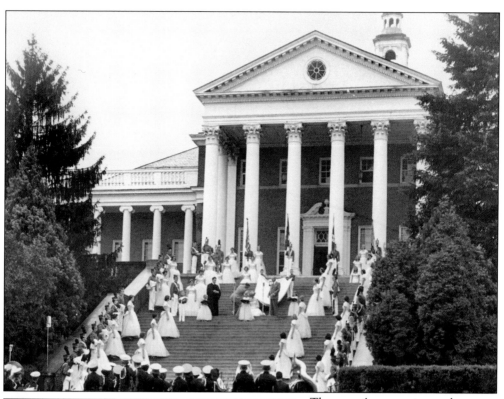

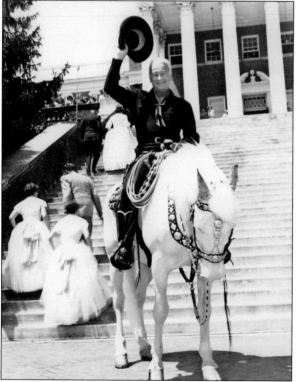

The queen's coronation at the 1953 Shenandoah Apple Blossom Festival took place at Handley Bowl. Queen Shenandoah was Kathryn Eisenhower of Charleroi, Pennsylvania, niece of former president Dwight D. Eisenhower. Gen. James A. Van Fleet, U.S. Army Ret., Minister of the Crown, presided. Maids of honor were Ann Farrar Arthur and Diane Stinson Hunt. Little maids were Katherine Boyd Glaize, Mary Sewell Hyde, and Ann Rhodes Shockey. (Courtesy Bill Madigan Collection.)

Hopalong Cassidy was William Boyd's television name. He greeted his fans in 1953, while festival princesses climbed the Handley High School steps behind him. Bond Bread sponsored Boyd for the festival. He rode in the grand feature parade and threw mini loaves of bread to the children on the sidelines. (Courtesy Bill Madigan Collection.)

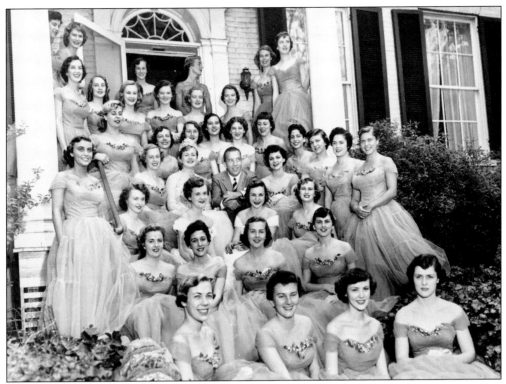

In 1954, Ed Sullivan was the grand marshal of the Apple Blossom parade. Sullivan was host of CBS's *Toast of the Town*. He is shown here with Apple Blossom Queen Patricia Ann Priest, daughter of the secretary of the treasury. Another celebrity who delighted festivalgoers that year was Johnny Roventini, or "Johnny," the man who represented Philip Morris as a hotel bellhop in their television ads. (Courtesy Bill Madigan Collection.)

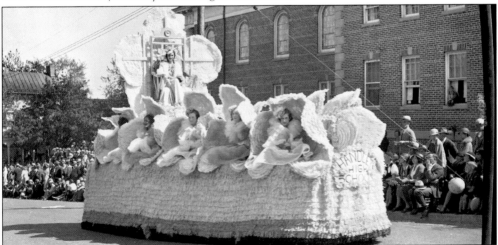

This Handley High School float in an early 1930s Apple Blossom Festival parade carried 10 apple blossoms, with a young woman inside each blossom. Behind a large blossom at the top, another woman sat facing the others. In this photograph, the float is making its way north along Fairmont Avenue, the old parade route from the Frederick County Fairgrounds. (Courtesy Bill Madigan Collection.)

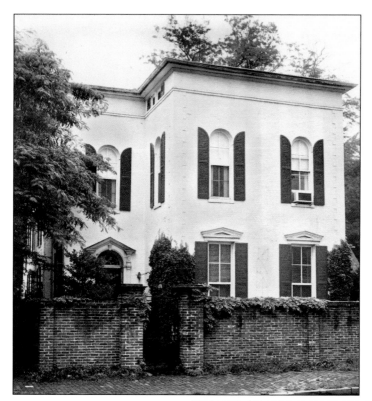

Holly House, located at 230 West Boscawen Street, was the home of Dr. E. C. Stuart Jr. and his wife, Meredith, from 1940 to 1962. George W. Seevers built this handsome house about 1850. In 1862, Union general Nathaniel P. Banks used it as his headquarters. In 1875, Maj. Holmes Conrad owned the house. (Courtesy *The Winchester Star.*)

This was the desk and den where Dr. E. C. Stuart worked in Holly House at Stewart and Boscawen Streets. The desk is a fine example of local carpentry. Stuart was a surgeon, and he had his office across the street from the emergency room of the hospital. His grave marker reads: "A soldier who grew flowers / A physician who healed the sick / A sportsman who loved life." (Courtesy *The Winchester Star.*)

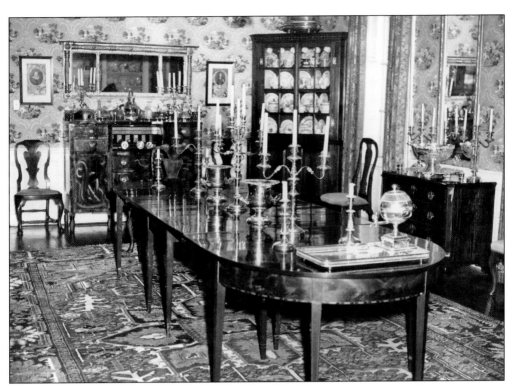

The Stuarts' dining room at Holly House displayed a large collection of 18th-century English and other silver. Those who remember the Stuarts say they would sit at the far end of the table to dine. In recent years, this house at Stewart and Boscawen Streets has served as a medical office. (Courtesy *The Winchester Star.*)

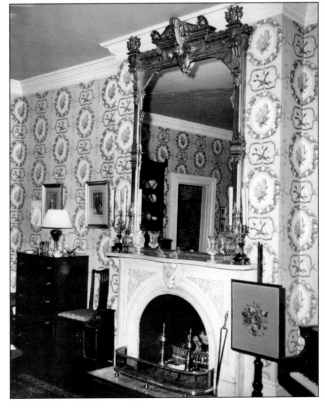

The Stuarts' formal parlor in Holly House, located at 230 West Boscawen Street, was at the front of the house, and the windows facing Stewart Street were to the right of the piano. There was a large mirror on the mantel over the working fireplace. The wallpaper was typical for this period. In 1962, Drs. Robert C. Green and W. J. Helm bought the house. (Courtesy *The Winchester Star.*)

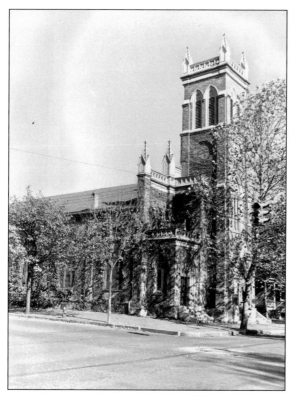

Christ Episcopal Church was built about 1828 at 138 West Boscawen Street. Bodies interred beneath an earlier church (Frederick Parish Church) were reinterred in Mount Hebron Cemetery. An exception was Thomas, Lord Fairfax, member of the colonial church, whose bones were eventually moved to a large tomb in the churchyard. The church architect was Robert Mills, designer of the Washington Monument. (Barr's Studio; courtesy Stewart Bell Jr. Archives.)

In 1753, German Lutherans built a log schoolhouse where Mount Hebron Cemetery now stands. A church cornerstone was laid at that location in 1764. In 1785, Christian Streit became pastor and served for most of the next 25 years. The congregation moved to the Lutheran church (shown here) at 20 West Boscawen Street in 1843 and adopted the name "Grace" in 1877. (C. Fred Barr, photographer; courtesy Stewart Bell Jr. Archives.)

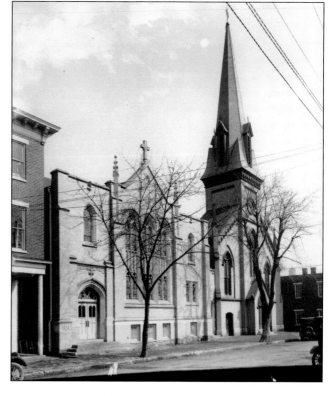

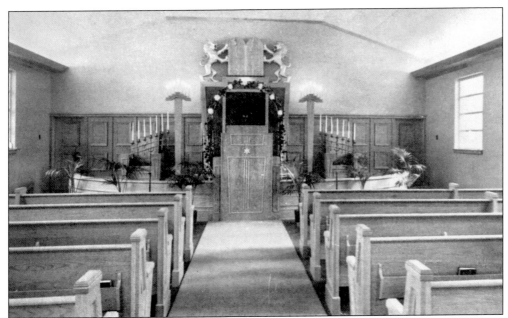

Beth-El Congregation, at 502 Fairmont Avenue, serves as a place of worship and community center for the Jewish people of the area. The synagogue-building project was undertaken by A. J. Novick, Charles Zuckerman, Abe Cooper, Seymour Barr, and Ben Belchic. The synagogue was paid for by member pledges and built in 1954. Before it was built, the congregation met at the Odd Fellows Hall on Boscawen Street. (Courtesy Charles Zuckerman.)

John Mann United Methodist Church at 119 East Cork Street replaced a log church and was dedicated in 1858 for worship by African American members. The land was donated by John Mann, who was buried beneath the church. It was controlled by Market Street Methodist Church until 1893, when it was finally transferred to the John Mann Trustees. All persons are welcome at the church. (Courtesy Stewart Bell Jr. Archives.)

St. Paul African Methodist Episcopal (A.M.E.) Church was organized in 1867 in the home of Randolph and Katherine Martin. The church shown here was built 20 years later at 428 North Loudoun Street. The congregation still worships in this church. In 1986, exactly 119 years after it was constructed, the building was declared a Winchester historic site. (Elaine Redman, photographer; courtesy Stewart Bell Jr. Archives.)

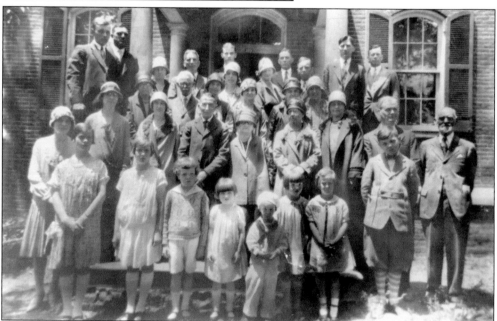

A group of Quakers stands on the steps of the Winchester Centre Meeting in 1925. Many Quakers were early settlers of Winchester, and there were two earlier meetinghouses. After the second was irreparably harmed in the Civil War, this building at Washington and Piccadilly Streets opened in 1872. The building has two doors, a throwback to when men and women held separate business meetings. (Courtesy Stewart Bell Jr. Archives.)

Six

FACES OF WINCHESTER

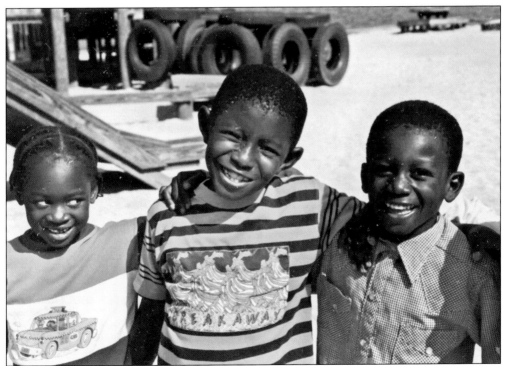

The faces of Winchester have included migrant workers ever since apples became a major local industry. In this 1991 photograph, Rebekah (left), Gary (center), and Daniel (right), all migrant children from Haiti, are having a good laugh at Christianson Family Land in Jim Barnett Park. Their families helped make the apple industry hum. (Courtesy Katy Pitcock, Migrant Education Program.)

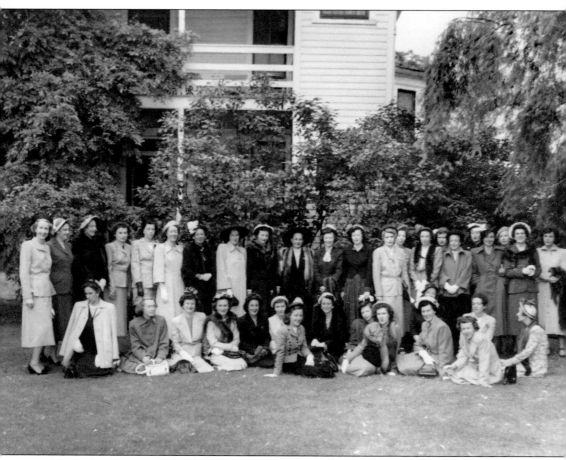

The Junior Century Club, which began in 1932, was affiliated with an older literary group called the Century Club. Junior Century Club members pose for a photograph outside on a beautiful day in the 1940s. From left to right, they are: (first row) Issy Engle, Gretchen Byrd, Marian Bell, Helen Adams, Lib Glaize, Mary Hyde, Dotty McGuire, Mary Steck, Eleanor Scully, Kathy Schroth, Kit Robinson, Jane Taylor, Chic Nelson, Carolyn Carson, and Brookie Benham; (second row) Virginia Sargent, Emily Kuykendall, Elizabeth Barr, Bennie Scully, Mary Virginia Steck "Chichi" Kern, Nell Kalbach, Ri Sjostrom, Harriet Rhodes, Wardie Carson, Ruth Funkhouser, Dolly Glaize, Teresa Massie, Rosalie Bell, Betsy McMullan, Dix Barr, Kandy Largent, Nancy Lawrence, Meredith Stewart, Sue Hedrick, Kitty Cooper, Jinny Holland, and Licky Bauserman. (Courtesy Stewart Bell Jr. Archives.)

In 1976, King Hiram Lodge No. 53 A.F. and A.M., Winchester's Prince Hall Masons, gathered. Members were, from left to right, as follows: (first row) John B. Cook, Robert L. Cross, Earl H. Coates Jr., Garfield Prather, Albert Martin Jr., Robert P. Johnson, Ellsworth Turner, and William H. Brown Sr.; (second row) Herman Jackson III, Calvin Gant Sr., Arlington Turner, Douglas Robinson, William Robinson, Jasper Long, and Robert Moten Sr. (Courtesy Stewart Bell Jr. Archives.)

In 1869, Fairfax Hall opened at 112 South Cameron Street. Students and teachers are shown c. 1899. The seated woman in black is probably Mary Billings, principal. The man is thought to be George Shepard, future principal. Others shown, order unknown, are Helty Jacobs (visiting), Emma Wilson, Lulla? Stump, Lulla? Jacobs, Miss Porter, Minnie Miller, Minnie Crum, Linda Jacobs, Bessie Woodall, Katie Woodall, and Lilla Wright. (Courtesy Stewart Bell Jr. Archives.)

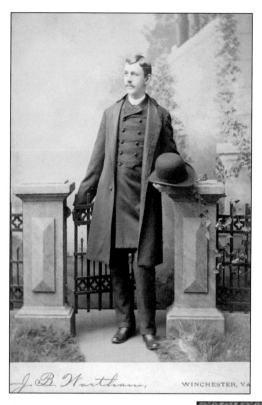

Stewart Bell (1864–1948) was a pioneer orchardist in Frederick County on Cedar Creek Road and was a director for Winchester Cold Storage. He served on the Winchester school board from 1914 to 1948 and was chairman from 1942 to 1948. He was the father of Winchester mayor Stewart Bell Jr. This picture was taken about 1888–1890. (J. B. Wortham, photographer; courtesy Stewart Bell Jr. Archives.)

Cornelia Jane Shuler Dietz (1832–1903) of Winchester is photographed during the Civil War era in her lace collar and fringe-trimmed cape. She was married to George Dietz in 1856. Their first three children were born in Winchester and didn't live past childhood. The next two children lived to adulthood. Charles Lee was born in 1865 and Alice Virginia in 1867. (Daguerreotype, c. 1858; courtesy Sue and Martin Dietz.)

Stewart Bell Jr., who was mayor of Winchester from 1972 to 1980, was often called "Mr. Winchester." He was a teacher, orchardist, historian, gentleman, and a gentle man. He had a wonderful sense of humor and a lifelong affection for Handley Library. Bell said, "No one needs to be ignorant or uninformed with access to a public library." He was instrumental in establishing the archives and left a charitable remainder trust. (Courtesy Stewart Bell Jr. Archives.)

George Peter Dietz (1830–1869) of Winchester was a cabinetmaker who also made caskets and wagons in Winchester and Front Royal. He married Cornelia Dietz in July 1856 in Winchester. In the late 1860s, Dietz moved to Baltimore, where he and his brothers ran Dietz Brothers Furniture. He died of tuberculosis. (Daguerreotype, c. 1858; courtesy Sue and Martin Dietz.)

After the Civil War, Holmes Conrad (1840–1915) studied law in Winchester and was admitted to the bar in 1866. He was a brilliant lawyer who was appointed solicitor general of the United States in 1895. Conrad, a friend of philanthropist John Handley, was president of the Handley Board of Trustees. He also lectured at Georgetown University. He was buried in Mount Hebron Cemetery. (Courtesy Handley Board of Trustees.)

Anne Tucker McGuire, daughter of Dr. Hunter H. McGuire, consulted with Dr. Alfred David Henkel (1861–1947) in his home at 29 South Cameron Street. Henkel was a local physician, historian, and genealogist. McGuire married Thomas M. Booth and moved to London. She enjoyed a distinguished career as an actress in England. She played the bride in the 1936 British film *Strangers on Honeymoon*. (Jolliffe Studio, photographer; courtesy Stewart Bell Jr. Archives.)

On November 7, 1886, one of the greatest baseball players in the history of the game was born in Winchester. If it had not been for his skin color, Spotswood Poles would certainly be in the Baseball Hall of Fame. He played in a precursor to the Negro leagues, often in Cuba, where whites and blacks could play against each other. Although he was only five feet seven inches tall, he was a blazingly fast outfielder with a wicked bat. His batting average against black pitchers was .472. Against white big-league pitchers, Poles had 25 hits in 41 at-bats, an astounding average of .621. He volunteered for the army and served in World War I. Poles retired from baseball in 1923, too soon for him to play in the Negro leagues. He returned to his native Winchester, living for a time at 30 Fremont Street, and drove a taxi. Poles later moved with his beloved wife, Bertha, to Harrisburg, Pennsylvania, where he had once played baseball. He died there on September 12, 1962, and was buried in Arlington National Cemetery. (Courtesy Stewart Bell Jr. Archives.)

Elizabeth Helm was Winchester's first Republican mayor (1988–1992) in over 80 years. She studied political science at Wellesley, and early in her life, she became a leader and a pacesetter. Helm broke through the male-dominated town politics and became the first female mayor. She played a large role in preserving Civil War battlegrounds in the Winchester area and in saving and opening the historic Kurtz Building. (Courtesy Stewart Bell Jr. Archives.)

Mayor Elizabeth A. Minor's 2004 campaign slogan was "Experience Counts." She had served in city-council positions since 1980 and became vice mayor in 1992. She volunteers for the North End Citizens Association and the Boys and Girls Club of the Northern Shenandoah Valley. Her campaign goals included reducing traffic congestion, keeping taxes low, and putting the Drug Abuse Resistance Education (DARE) program back in schools. (Courtesy City of Winchester.)

"Billy" Madigan and his father, George Leonard Madigan, were feeding chickens in their backyard at 522 North Braddock Street about 1944. As an adult, Madigan remembers that in 1947, the circus came to town. The train stopped next to Winchester Cold Storage to unload the circus. He watched the performers inside the lighted passenger cars. The next day, the elephants and performers paraded past his house. (Courtesy Bill Madigan Collection.)

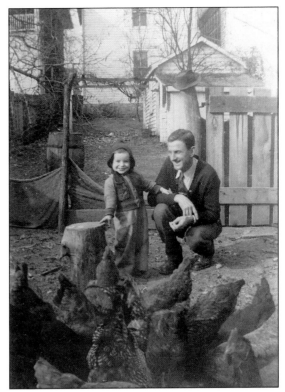

This is the backyard of 522 North Braddock Street in 2005, and the man in the foreground is Bill Madigan. The building is now an apartment house, and the deck is new. Madigan can remember lying in the grass about 1946 and looking up to see dirigibles course their way across the sky. (Courtesy Bill Madigan Collection.)

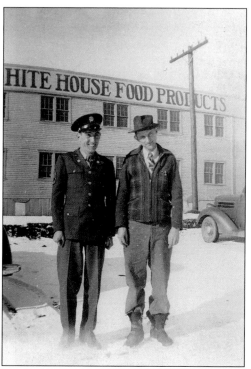

Reuel M. Madigan, army air corps, and brother George Leonard Madigan "Maddie," employee of National Fruit Product Company, stand in front of the plant in 1944. This building held executive offices, including that of Frank Armstrong Sr. Later, when a new building was built, National Fruit temporarily moved their offices to the George Washington Hotel. (Courtesy Bill Madigan Collection.)

Mayor Anderson hands the key to Winchester to a silent-film-cowboy star in the early 1930s. Dr. Charles R. Anderson was mayor from 1932 to 1946. The Conrad house is on left and the Kurtz Building on right. They are standing in front of Rouss City Hall, 15 North Cameron Street. The World War I cannon was given by the city to be used as scrap metal for World War II. (Courtesy Bill Madigan Collection.)

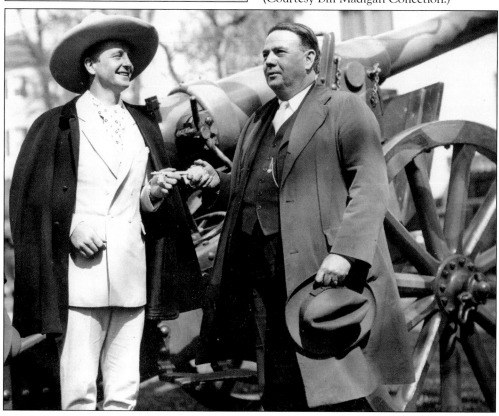

Frederick County Fruit Growers Association, a growers' cooperative, provides housing and work for the fruit pickers. A labor camp is located next to National Fruit Product Company on Fairmont Avenue. Classes at the camp were taught by several women. This photograph, taken in 1994, shows the children assembled for a Saturday enrichment program. Katy Pitcock (left) and Pam Wrigley (right), teachers, appear in the back row. (Courtesy Katy Pitcock, Migrant Education Program.)

Mary, a classroom aide, and Maggie Altidore work together at Quarles Elementary School, located at 1310 South Loudoun Street, in 1988. Before the 1980s, the migrants who came to pick the apples were African American and came from Florida. More than 1,000 individuals have lived at the labor camp at its fullest. Two-thirds of the orchards have disappeared in recent years. In 2005, only 450 workers were needed. (Courtesy Katy Pitcock, Migrant Education Program.)

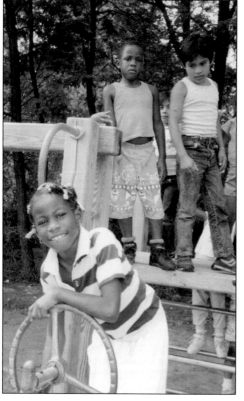

Migrant children (counter-clockwise from bottom) Julio, Giovanni, Edwin, Ernesto, and Eddie listen to teacher Sandy Widell at Quarles Elementary School in 1989. Home-school coordinator Lora Annunziata observes. From about 1988, Latinos from Mexico increased as a percentage of the migrant workers. The children come from tight family units with traditions of authority, which prepare them for preschool. Many speak two languages—Spanish and the indigenous language of their village. (Courtesy Katy Pitcock, Migrant Education Program.)

Pedrick Guerrier from Haiti (left) and Celerino from Oaxaca, Mexico, play with an African American friend from Florida in 1990. Migrant workers come from many places now, especially Mexico. Latinos coming to the Shenandoah Valley arrive from all parts of Mexico. Some of the children of migrants graduate from the local schools. Some go on to higher education. (Courtesy Katy Pitcock, Migrant Education Program.)

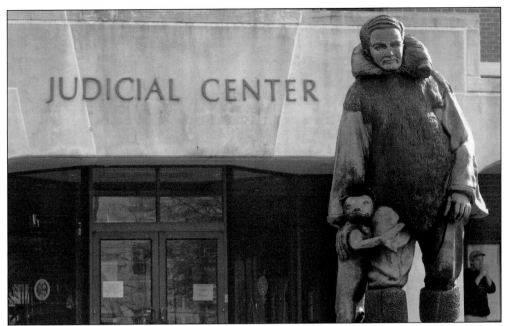

This eight-foot bronze statue of Adm. Richard Byrd stands at the Joint Judicial Center in Winchester. It depicts the famous explorer and aviator dressed for the Antarctic with his dog Igloo. Demonstrating great courage, Admiral Byrd extensively explored the Antarctic. He also experimented with techniques and equipment that made it safe to navigate aircraft over the open ocean. His many awards included the Congressional Medal of Honor. (Courtesy Ronna M. Hoffmann, photographer.)

Jay Morton (1911–2003) sculpted the bronze statue of Admiral Byrd from a wax model that stood in Handley Library for many years. He personally unveiled the statue in 1997. In addition to being a sculptor, Morton was a screenwriter, cartoonist, and inventor. He coined "it's a bird, it's a plane, it's Superman!" as well as inventing the pop-top aluminum can with the stay-attached top. (Courtesy Stewart Bell Jr. Archives.)

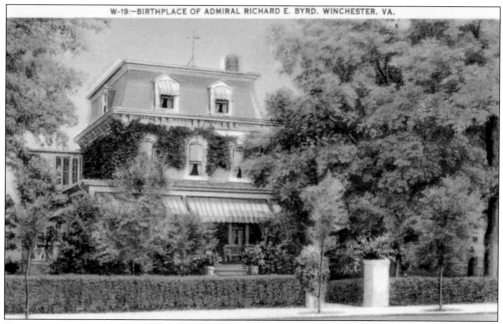

Renowned explorer Richard Byrd (1888–1957) was born in Winchester on October 25, 1888, and attended the Shenandoah Valley Academy. He took his first trip around the world (unaccompanied) at age 12. This house was the family home. Byrd's father was a prominent lawyer and politician who purchased the seven-bedroom Victorian house in 1887. It stood at 326 Amherst Street in Winchester and has since been demolished. (Courtesy Leighanne Zeigler.)

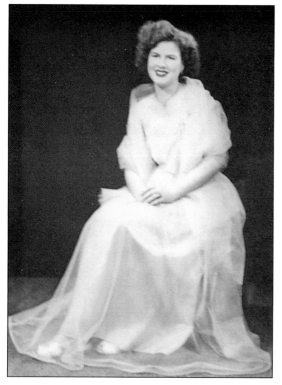

The haunting voice of Patsy Cline holds the same power to enchant today as it did when she began her career in Winchester and nearby towns. Her voice had, and has, a unique ability to connect with a lonely aching place that humans share. This direct connection to the audience had an enormous impact, first on country music and, ultimately, on the pop-music world. (Courtesy Stewart Bell Jr. Archives.)

Patsy Cline (1932–1963) was born Virginia Patterson Hensley on September 8, 1932, in Winchester Memorial Hospital. As a newborn, Cline lived in nearby Gore. Many of her early years were spent in this house at 608 South Kent Street, which is now on the National Register of Historic Places. She married her second husband in a house a few doors away. Cline attended Handley High School in Winchester. (Courtesy Ronna M. Hoffmann, photographer.)

Patsy Cline once worked at the soda fountain in Gaunt's Drug Store. Gaunt's contains a collection of memorabilia, which is the closest thing to a Cline museum in Winchester. It includes an original booth and an old jukebox, as well as newspaper articles and other objects. Not all of Winchester embraced the honky-tonk singer, and only now are plans in place for a museum in her memory. (Courtesy Ronna M. Hoffmann, photographer.)

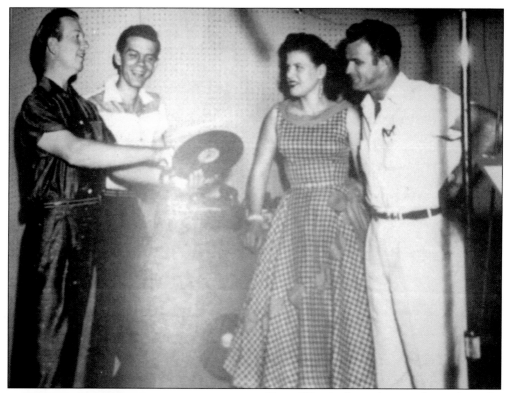

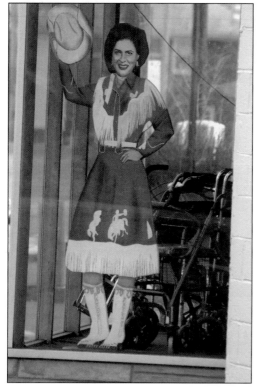

Patsy Cline is shown here in the studio with friends Rex Allen (left), Justin Tubb (center), and Arleigh Duff (right). In 1957, she sang on *Arthur Godfrey's Talent Scouts* television show. The appearance is credited for the country star's crossover to the pop charts. Cline's career ended only six years later in a fatal airplane crash, but her popularity and record sales continue to grow to this day. (Courtesy Stewart Bell Jr. Archives.)

Thirty-three years after her death, this life-size cutout of Patsy Cline stands in the window of Gaunt's Drug Store. The singer rose from appearances in local dance halls to achieve her dream of joining the Grand Old Opry in 1960. Cline was inducted into the Country Music Hall of Fame in 1973, and in 1993, the U.S. Postal Service issued a stamp with her likeness. (Courtesy Ronna M. Hoffmann, photographer.)

JOHN KIRBY
1937-1941
The Biggest Little Band

Born in Winchester, not Baltimore, as most authorities state, John Kirby (1909–1952) was born Johnny Kirk. He grew up in the home of Baptist minister Washington Johnson at 442 North Kent Street. Kirby was educated at Old Presbyterian School, where Prof. Powell W. Gibson taught him music. He decided to devote his life to music. Ambitious, he went to New York where he thought he could get a start. He was a success. He played with Fletcher Henderson's orchestra. Soon Kirby had his own band, which had commercial appeal in the late 1930s, and they played at the Onyx Club and the Apollo. Kirby put together highly skilled musical arrangements and directed the first black orchestra to use smoothly fused classical music with jazz. He had his own radio program in 1940 called *Flow Gently Sweet Rhythm*. The John Kirby Band members are, from left to right, O'Neil Spencer, Charlie Shavers, John Kirby, Buster Bailey, Russell Procope, and Billy Kyle. (Courtesy Stewart Bell Jr. Archives.)

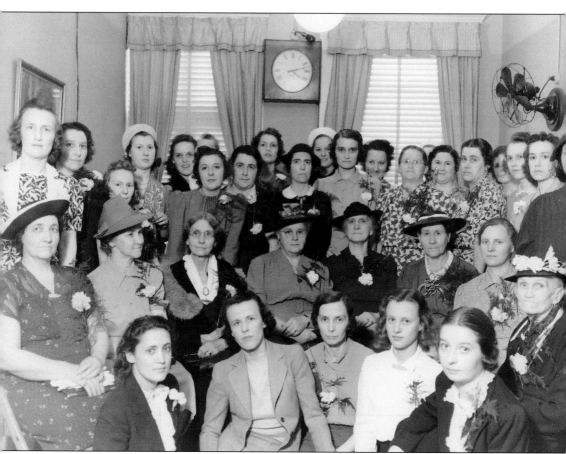

Winchester's Chesapeake and Potomac Telephone Exchange was located at 23 North Loudoun Street in 1939. The telephone operators who connected local calls worked with a long line of 12 to 13 switchboards hooked together. Effie Ashby Streit remembers her 47-and-a-half-year career with AT&T as a happy experience. She was among these operators and their mothers, who posed for a photograph at a Mother's Day celebration in May 1939. They are, from left to right, as follows: (first row) Alice Russel Fansler, Virginia Grove Naddeo, Elizabeth Wood Grim, Pauline Grant Green, and Margaret Lewis Croushorne; (second row) Mrs. Russel, Mrs. Fugit, Mrs. Grove, Mrs. Bywaters, Mrs. Wood, Nellie Spaid Brill, Mrs. Grant, and Mrs. Adams; (third row) Louisa Pingley, Ruth Hart, Gertrude Patton, Ella Louise Kremer Patton, Virginia Bywaters Kremer, Elizabeth Larew, Virginia Wood, Jessie Lupton, Alena Paulette Brill, Hazel Nelson, Elmadine Grimm Childs, and Mrs. Lewis; (fourth row) Jane Fugitt Morrison; Mrs. Jimmy Shiflett, Marie Anderson, Effie Ashby Streit, Catherine Ashby Scheder (Effie's sister), and Mrs. Henshall. (Courtesy Stewart Bell Jr. Archives.)

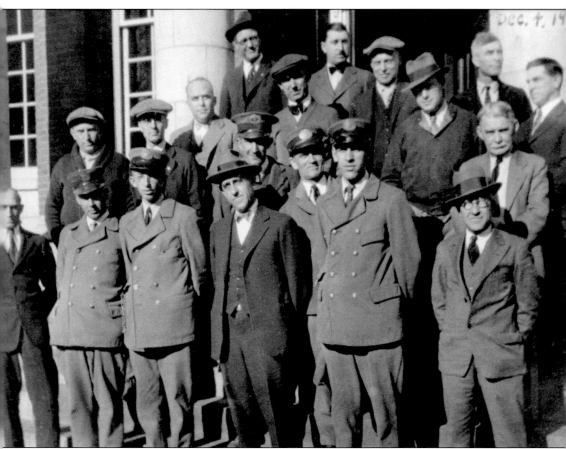

Standing outside the post office building at the northeast corner of Piccadilly and Braddock Streets, the 1930 Winchester Post Office employees are, from left to right, as follows: (first row) Robert L. Glaize, Joseph P. Miller, H. Clay Manuel, Harry C. Stouffer (postmaster), A. Ryland Conner, and Robert Grim; (second row) Lloyd "Jack" Darr (rural carrier), Wilbur R. Johnston, J. Augustus "Gus" Haines (carrier), Edward E. Peer (carrier), and Benjamin H. Potts; (third row) Thomas O. Warren, John H. Seal Jr. (carrier), J. Howard "Toot" Taylor, and Walter I. Cooper (assistant postmaster); (fourth row) W. Avalon "Av" Orndoff, John H. Kern, Robert W. "Brud" Taylor (custodian), and Elmer Wingfield (custodian). (Courtesy J. Floyd Wine.)

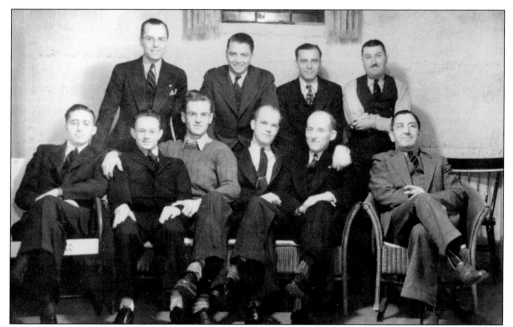

The male postal employees of the 1939 Winchester Post Office are, from left to right, as follows: (seated) J. Floyd Wine, Robert L. Jones Jr., Vincent Noonan, Taylor F. Simpson, J. Ellwood Snyder, and Herman M. See; (standing) Wilbur R. Johnston, Carl L. Campbell, Edward H. Koons, and John H. Kern. This photograph was taken in John H. Kern's home on Morningside Drive. (Courtesy J. Floyd Wine.)

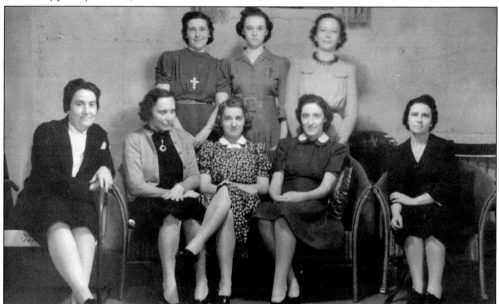

The ladies auxillary of the 1939 Winchester Post Office are, from left to right, as follows: (seated) Sydney E. See, Katherine Kern, Sarah (Sally?) Simpson, Marguerite Campbell, and Vergie C. Johnston; (standing) Vernie Snyder, Princess Strother Jones, and Cornelia Sutphin Koons. This photograph was taken in John H. Kern's home on Morningside Drive. (Courtesy J. Floyd Wine.)

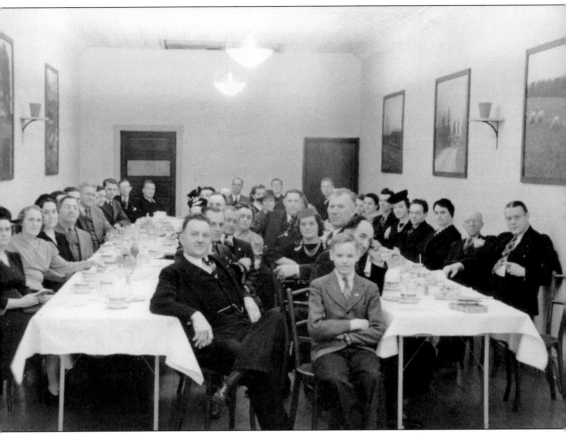

This mail dinner took place in Shirkey's Restaurant on South Loudoun Street across the street from the Palace Theatre between 1937 and 1943. From left to right are the following: (first row) Virgie C. Johnston, Maude R. Conner, Sydney E. See, Herman M. See (clerk), two unidentifieds, W. Avalon Orndoff (clerk), Marguerite Campbell, Carl L. Campbell (clerk), H. Clay Manuel (carrier), and W. Nelson Page (postmaster); (second row) Everett D. Kline (carrier), Wilbur R. Johnston (clerk), Leslie E. Fries (rural carrier), and Ethel M. Fries; (third row) unidentified, J. Augustus Haines (carrier), John H. Seal Jr., Ruby Funk, Lloyd R. "Jack" Darr? (rural carrier), Cora E. Darr?, unidentified, and J. Floyd Wine (clerk); (fourth row) J. Howard "Toot" Taylor (superintendent of mails), Clarence L. Peffer (carrier), ? Peffer, Robert L. Jones Jr. (clerk), Princess Strother Jones, Arthur W. Spaid? (carrier), two unidentifieds, and Richard E. Owen (carrier who died on D-Day). (Courtesy J. Floyd Wine.)

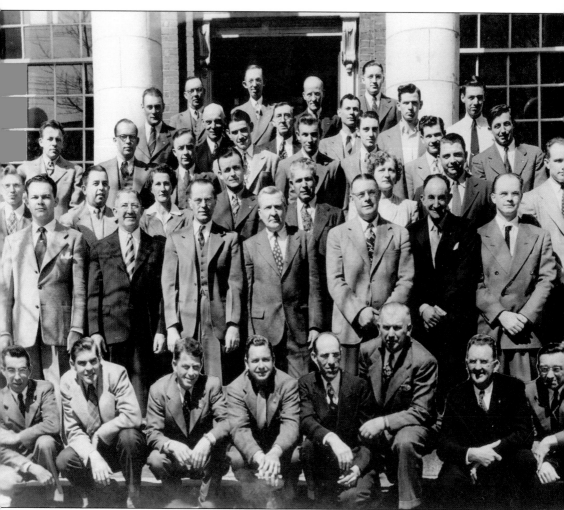

Winchester Post Office employees of the Piccadilly and Braddock Street post office in 1948 are, from left to right, as follows: (first row, added later) Eugene F. Goss, John R. Gregory, John F. Birmingham, Edward C. Jackson, A. Ryland Conner, John H. Seal Jr., Everett D. Kline, and George W. Jones; (second row) Harold L. Foreman, Herman M. See, Wilbur R. Johnston (assistant postmaster), W. Nelson Page (postmaster), J. Howard "Toot" Taylor (superintendent of mails), J. Augustus "Gus" Haines, and Taylor F. Simpson; (third row) Leonard S. Newlin, Joseph C. Haines, Ruth McCann Owen Milhollen, John H. Quick Jr., S. Ray Willey, Effa R. Link, Carl L. Campbell, and Jonas O. Chamberlin Jr.; (fourth row) Ivan P. Kline, Joseph Ray Miller, E. Maurice Grim, Leslie A. Carper, Charles W. Bush, Roger E. Laign, Ralph E. Lamp, and William R. Mitchell; (fifth and sixth rows) Charles M. Dick, Joseph P. Miller, Robert W. "Brud" Taylor, H. Clay Manuel, Roland E. Buncutter, J. Ellwood Snyder, Arthur W. Spaid, J. Floyd Wine, Clarence F. "Salty" Hoover, and Richard E. Stine. (Hugh G. Peters, photographer; courtesy Stewart Bell Jr. Archives.)

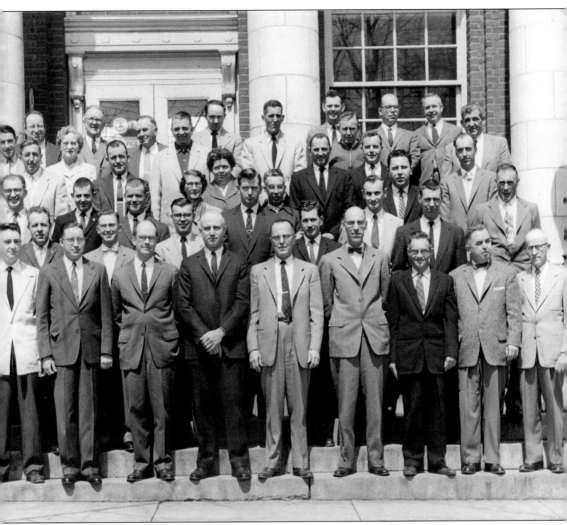

Winchester Post Office employees standing on the steps of the Piccadilly and Braddock Street post office in 1958 are, from left to right, as follows: (first row) Roger E. Laign, J. Floyd Wine, Taylor F. Simpson (assistant postmaster), Jonas O. Chamberlin Jr. (superintendent of mails), Wilbur R. Johnston (postmaster), A. Ryland Conner, Robert L. Jones Jr., Joseph C. Haines, and J. Elwood Snyder; (second row) Ivan P. Kline, Leonard S. Newlin, Donald G. Bush, Ralph E. Lamp, and Richard E. Stine; (third row) Steve Forgacs, C. Edward "Eddie" Manuel, W. Henry Thompson, Ruth McCann Milhollen, Clarence F. "Salty" Hoover, Eugene F. Goss, Charles W. Bush, and Charles M. Dick; (fourth row) William R. Mitchell, John H. Quick Jr., Helen G. Zeilor, James F. Huyett, P. Richard Wolfe, Harry Howdershell, and Norwood W. Dusing; (fifth row) Leslie A. Carper, Effa R. Link, Charles Zeilor, Carl L. Campbell, Berlyn E. Moore, Philip Rainiberger, and Holmes Bucher; (sixth row) Howard L. Garber, Everett D. Kline, Olin R. Stultz, Arthur W. Spaid, Joseph Ray Miller, and Edward C. Jackson. (Courtesy Stewart Bell Jr. Archives.)

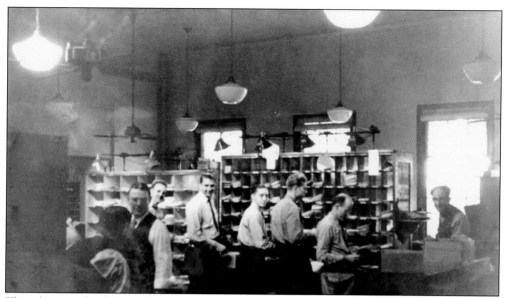

This photograph of the mail room at the Winchester Post Office was taken between 1937 and 1943. From left to right are J. H. "Toot" Taylor (superintendent of mails), Everett D. Kline, Carl L. Campbell, J. Floyd Wine, Richard E. "Dick" Owen, J. Ellwood Snyder, and Gus Haines (carrier standing in front of the window). (Courtesy J. Floyd Wine.)

Douglas Palmer (left) and Tom D. Halterman (right) raise the chamber of commerce shingle at its 29 South Cameron Street location. Halterman was well known as a very talented sign painter who could also work with gold leaf. His daughter, Betty Jo Dickerson, is 2004–2007 regent of Fort Loudoun Chapter of the Daughters of the American Revolution. Palmer is now in business for himself as Palmer Signs in nearby Bunker Hill, West Virginia. (Courtesy *The Winchester Star.*)

Seven

TODAY

Stewart Bell Jr. Archives, located on the Web at www.hrl.lib.state.va.us, is a research facility that houses manuscripts with inventories and materials about the people and the history of the lower Shenandoah Valley (the northern valley counties). This unique collection includes original account books and deeds, insurance certificates, diaries and letters, newspapers, maps, photographs, and much more. Researchers whose ancestors traveled the Great Wagon Road make this repository a primary destination. (Courtesy Stewart Bell Jr. Archives.)

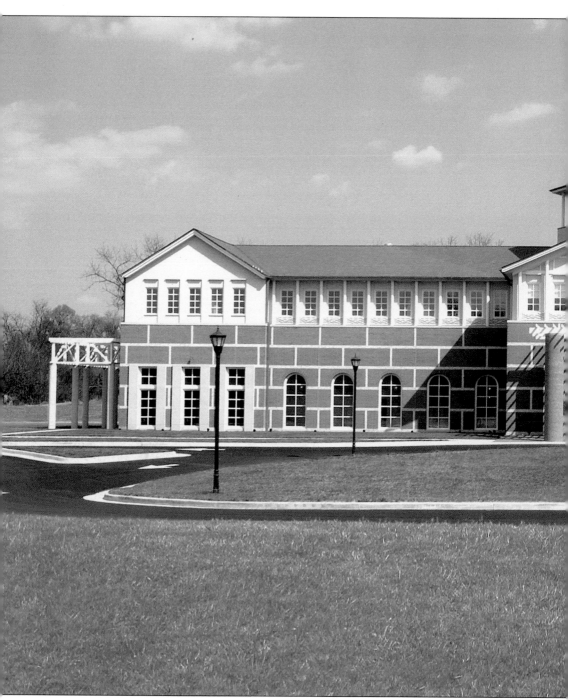

Today the Museum of the Shenandoah Valley joins Glen Burnie Historic House and Gardens to form a regional history museum complex that tells the story of the Shenandoah Valley. Located on the historic Glen Burnie property, the museum opened in the spring of 2005 and was designed by Michael Graves of the internationally renowned architectural firm of Michael Graves and Associates. The first level contains the main lobby, learning center, tea room, and museum store. The second level contains four galleries. The Shenandoah Valley Gallery explores valley history,

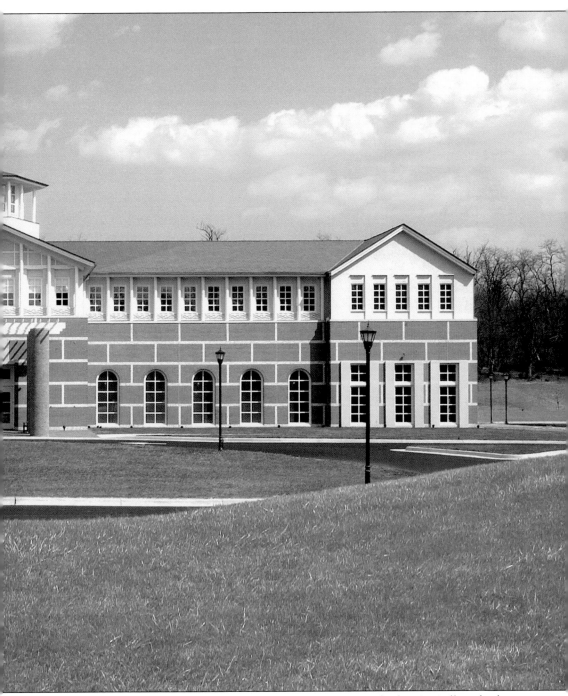

including local decorative arts from the mid-1700s. The Julian Wood Glass Jr. Gallery displays significant paintings, furniture, and objects. The R. Lee Taylor Miniatures Gallery presents furnished miniature houses created in Winchester. The Changing Exhibitions Gallery features exhibits on valley topics. This Winchester treasure can be explored online at www.shenandoahmuseum.org. (Ron Blunt, photographer; courtesy Museum of the Shenandoah Valley.)

In 2005, Winchester won recognition from the National Civic League as an All-America City. This recognition highlighted the success of three government-community partnerships: the "Our Health" health and human services complex; the Boys and Girls Club of the Northern Shenandoah Valley caretakers unit; and "Mission: Communicate," an initiative that illustrates the city's efforts to serve the growing Latino population by providing language access. The Winchester delegation, made up of individuals connected to these programs, accurately reflected the diversity of the growing community and provided a unique opportunity for collaboration across ethnic, social, and economic backgrounds. The All-America team members are, from left to right, as follows: (first row) Joey Fraction, Bryan De La Cana, Ashanti Day, and Saul De La Cana; (second row) Ed Daley, Shyama Rosenfeld, Amy Simmons, Sharen Gromling, America Barbosa, and Charlotte Fritts; (third row) Paul Brown, Joe Shtulman, Dale Brown, Heather Enloe, Leah Nelson, Chucky Newman, Charlie Gaynor, Judy Landes, Craig Smith, Sherri Jones, Jonathan Jones, John Jones, Traci Day, Licette Martinez, Larry VanHoose, Bob Kendall, Robert Witherall, Erin Elrod, and Rick Ours. (Courtesy City of Winchester.)

In this 2006 picture, the old Union Bank of 1870 is now a jeweler's shop, and an upscale restaurant beckons to passersby. Nearby new paintings of the area link past to present at the Eugene B. Smith Gallery. Loudoun Mall and the historic district have restaurants, galleries, and shops to entice modern shoppers. The Old Town Development Board is responsible for development of Old Town Winchester. (Courtesy Ronna M. Hoffmann, photographer.)

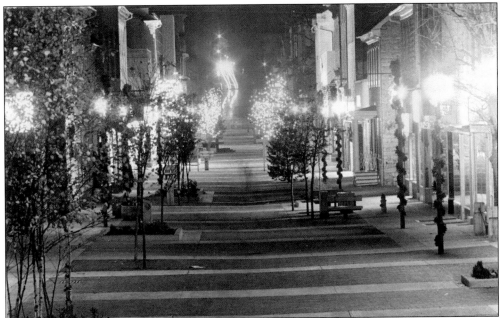

Part of Loudoun Street is now a pedestrian mall. Loudoun Street was one of only two streets in the 1744 plan for the town. Over 260 years later, it continues as Winchester's main street (once it was actually named Main Street.) Citizens gather here for communal activities, including First Fridays Celebration of the Arts, New Years Eve First Night, and the Bluemont Summer Concert Series. (Courtesy *The Winchester Star*.)

SELECTED BIBLIOGRAPHY

Barr, Betty. Telephone interview, February 2006, regarding history of Beth-El Congregation.

Byard, Wayde. Lecture at Coalition for Racial Unity meeting, February 2006, regarding the life and record of baseball player Spotswood Poles.

Foreman, Michael M. *History of Winchester Memorial Hospital Training School for Nurses 1903–1964 Winchester, Virginia.* Winchester: self-published, 1990.

Hofstra, Warren R. *The Planting of New Virginia—Settlement and Landscape in the Shenandoah Valley.* Baltimore: The Johns Hopkins University Press, 2004.

Lee, Marge, research by Leila O. W. Boyer, photography by Ron Blunt. *The Gardens of Glen Burnie—The History and Legends of a Virginia Legacy.* Winchester: The Glass–Glen Burnie Museum, Inc., 2003.

Miller, Virginia Lindsay and John G. Lewis. *Interior Woodwork of Winchester, Virginia 1750–1850 with Some History and Tales.* Winchester: privately published, 1994.

Quarles, Garland R. *George Washington and Winchester, VA 1748–1758.* Winchester: Winchester–Frederick County Historical Society, 1974.

———. *John Handley and the Handley Bequests.* Winchester: Winchester–Frederick County Historical Society, 1969.

———. *Occupied Winchester.* Winchester: Winchester–Frederick County Historical Society, 1991.

———. *Some Worthy Lives.* Winchester: Winchester–Frederick County Historical Society, 1988.

———. *The Story of One Hundred Old Homes in Winchester, Virginia.* Winchester: Winchester–Frederick County Historical Society, 1993.

———. *Winchester, VA: Streets, Churches, Schools.* Winchester: Winchester–Frederick County Historical Society, 1996.

Ritter, Ben. "Jackson's First War-time Portrait, The Widow's Favorite—A Rare Photograph of 'Stonewall' the Legend," *Civil War Times Illustrated,* February 1979.

Russell, William Greenway. *What I Know About Winchester.* Staunton, VA: Winchester–Frederick County Historical Society, 1953.

Schaefer, John C. III. Interview October 15, 2003, with Elizabeth "Betsy" Helm, Ann Denkler Collection, Stewart Bell Jr. Archives.

Taylor, James E. *With Sheridan Up the Shenandoah Valley in 1864: Leaves from a Special Artist's Sketchbook and Diary.* Cleveland: Western Reserve Historical Society, 1989.

A *Walking Tour of Historic Winchester.* Winchester: Preservation of Historic Winchester, Inc., 1976.

Williams, Alan. *Fall from Grace: The John Kirby Story.* Pensacola, FL: Alcoral Books, 1996.

———. *Flow Gently, Sweet Rhythm—John Kirby and His Famous Sextet (The Biggest Little Band in America).* Norfolk: self-published, 2006.

INDEX

DISCOVER THOUSANDS OF LOCAL HISTORY BOOKS
FEATURING MILLIONS OF VINTAGE IMAGES

Arcadia Publishing, the leading local history publisher in the United States, is committed to making history accessible and meaningful through publishing books that celebrate and preserve the heritage of America's people and places.

Find more books like this at
www.arcadiapublishing.com

Search for your hometown history, your old stomping grounds, and even your favorite sports team.

Consistent with our mission to preserve history on a local level, this book was printed in South Carolina on American-made paper and manufactured entirely in the United States. Products carrying the accredited Forest Stewardship Council (FSC) label are printed on 100 percent FSC-certified paper.

MADE IN THE
USA